T0355964

Vivienne
WESTWOOD

Vivienne WESTWOOD

The ILLUSTRATED WORLD OF a Fashion VISIONARY

by TOM RASMUSSEN

Illustrated by MARTA SPENDOWSKA

Smith Street Books

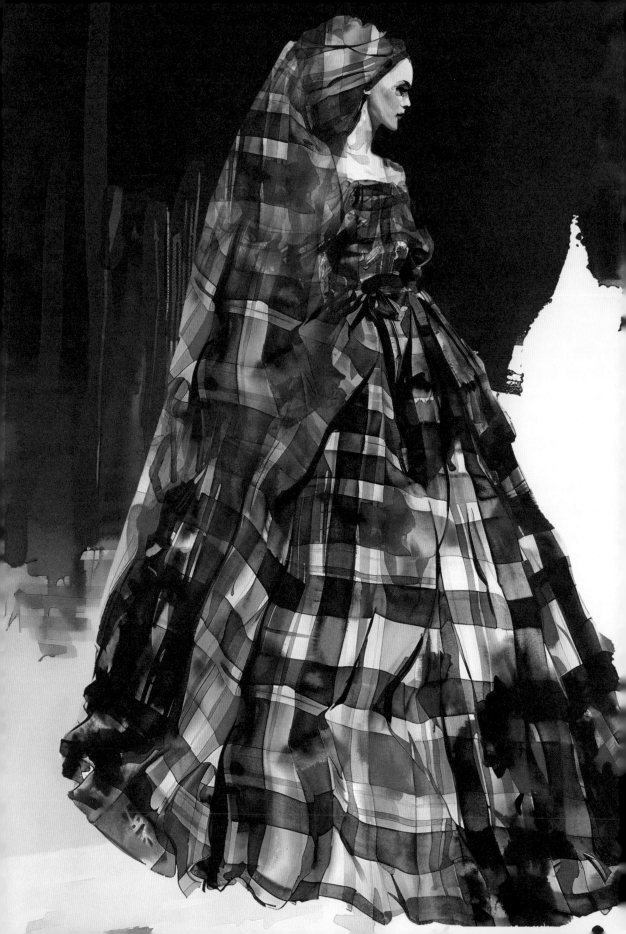

Contents

Introduction

CULTURE CHANGER

There is only one Vivienne Westwood. That seems like an obvious thing to say ... But, when fashion is a place where the emperor's new clothes are often the most sought-after item, Westwood managed to stay true, and truly original, throughout her five decades at the helm.

Indeed, there have been many attempts at imitating what Westwood did in her life – in terms of clothes, in terms of impact, in terms of how she not only reflected culture but changed it. But the problem for imitators is that what Vivienne Westwood created was far greater than the sum of its parts. The clothes were genius, the politics challenging, the insatiable need to rebel awe-inspiring – and the charm to pull it all off was there in spades. None of this could be taught at fashion college, none of this could be bought by consumers or paid for by big investors. And that's why Westwood remains one of the true originals: not only in fashion, but in culture, politics, activism and art. Because she wasn't for sale.

Her product – that is to say, the clothes she designed and sold – was almost the final link in an incredibly characterful and strong chain that made 'Westwood' what it is ... An idea. Something utterly modern, and yet obsessed with the past. Something that simultaneously looked forward and backwards, so it could stand in the present and comment on culture as it did. Be it in the way she dressed women, the punks or the New Romantics ... In the way she critiqued most British institutions, yet still had a pride in British culture and what it could be ... It was cerebral and practical ... Be it rips in her fabric, kilts, corsets or mega androgyny, nobody was doing it like this former primary school teacher from Derbyshire.

So, where did this sensibility come from? This wonderment in how things could be – how clothes could hang off the body, how dresses could be cut to actually fit women's forms, how we could all do more to make the world a better place. The commitment to hope that she retained until the end of her life: hope for a better world locally, in fashion, and for everyone.

Vivienne Westwood wasn't born a Dame. In fact, the beginnings of Vivienne Isabel Swire, born in 1941 near the industrial town of Glossop, Derbyshire, were a world away from the prestigious reputation – and the title of OBE – she'd go on to hold. Her upbringing was modest, her family working class: a perspective that would arguably inform both her love, and critique of, luxury throughout her life. Yet, within this seemingly ordinary upbringing simmered a potent mix of rebellion and a nascent creativity that would explode decades later.

In 1965 Westwood met Malcolm McLaren, an art student with a penchant for provocation. This meeting would ignite a creative firestorm that reshaped both Westwood and McLaren's lives and the cultural landscape around them. The pair went on to open a shop on London's legendary King's Road, called Let It Rock, where they sold vintage pieces – a deliberate rejection of newness, of buying and wasting, then buying more. But Westwood eventually grew tired of curation and began producing her own clothes, each item imbued with the raw energy she became so well known for, which at the time reflected the growing punk movement. Torn tops, bondage pants, safety pins – all became signature. And all – not accidentally – gave a middle finger to the establishment, to life and fashion in the seventies. For Westwood and McLaren, clothing was a weapon and their designs a visual manifesto, reflecting the fury of a generation disillusioned with the Vietnam War, stifling social inequality and a broken political system.

McLaren started to manage a band – the Sex Pistols – who became the living embodiment of this rebellious movement, and living mannequins for Westwood's work. The visual assault of Westwood's clothes amplified the band's music in its glaring abrasiveness, and together they exploded the music and fashion scenes of the late seventies. It was called 'punk' by the media, and that word would be forever entwined with Westwood's name.

Eventually, as did any good punk, she moved on to a new era – the New Romantics, and from there to pirates, and on and on. She imagined everything anew and never stayed in one place aesthetically, because her impact outshone mere trends and movements. Punk – and Westwood – wasn't really about torn-up outfits and razor-spiked hair. It was about challenging received ideals of beauty; it was about expression; it was about questioning why things have to be the way they are. At the time, the world was rigidly defined by gender and class – but punks embraced androgyny and reclaimed DIY aesthetics. For her whole career Westwood did the same. With each idea she challenged the norm, the expected, and created beauty by redefining it. She was punk in body, heart and mind until the end. And to wear Westwood was to declare your allegiance to a different way of thinking.

In the early nineties, Westwood married her young protégé, Andreas Kronthaler, who would become her long-term creative partner. The pair pushed each other on to be brilliant and inspired one another until the end of her life. Together they expanded the fashion house in countless ways. With Kronthaler at Vivienne's side, Westwood became a globally successful business, a beacon of sustainability, and remained a brand that was always ahead of its time.

'THE ONLY POSSIBLE
EFFECT ONE CAN HAVE ON
THE WORLD IS THROUGH
UNPOPULAR IDEAS.'

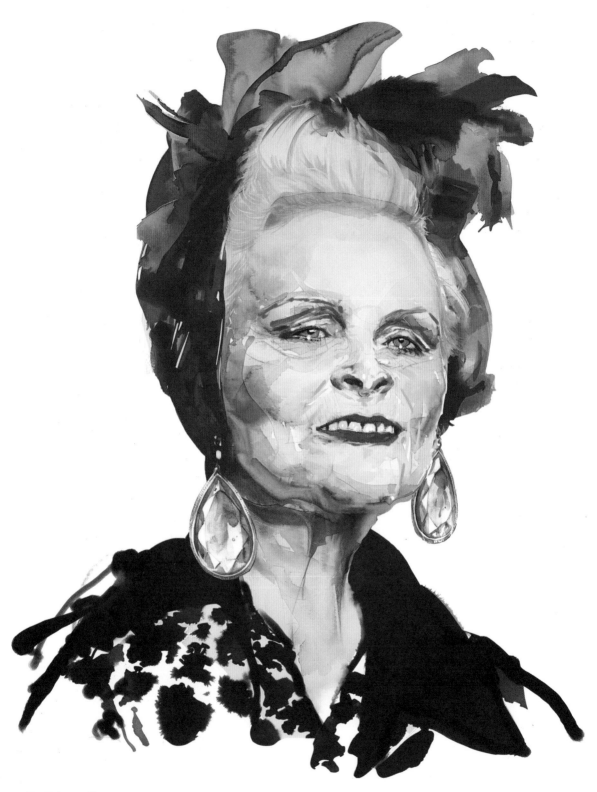

Westwood's story was one of resistance, of resisting everything – herself included. And so she grew out of each new obsession. She invented New Romanticism, then she obsessed over pirates; in one collection she would look at women on their way to work, in the next she would reinvent Marie Antoinette's corsets. Eventually, as the nineties came to a close, her life's work became entirely focused on climate and politics. There had always been an anti-establishment attitude to climate activism, but once Westwood gained a platform people listened. Each collection and each show after the millennium was no longer a veiled metaphor but, instead, a direct call to arms: to commit to radical climate action; to choose the world; to be a present, active citizen. Westwood was so committed to climate action that the title of 'designer' eventually seemed secondary to 'activist'.

Westwood's influence on fashion was seismic: there is no 'fashion' as we know it without her. Her legacy reaches far beyond ripped T-shirts and tartan kilts (although both are legendary staples in any Westwood wardrobe). Westwood democratised fashion – she made it about self-expression and about resistance. She said that anyone can be beautiful and anyone can be in fashion, if they stand for what's right. She believed in fashion as a catalyst for social change, using it – unwaveringly – to spark conversations about everything from politics to the environment.

'I DIDN'T CONSIDER MYSELF A FASHION DESIGNER AT ALL AT THE TIME OF PUNK. I WAS JUST USING FASHION AS A WAY TO EXPRESS MY RESISTANCE AND TO BE REBELLIOUS.'

Chapter 1
BEFORE
the STORM

Vivienne Isabel Swire, born
in 1941, emerged from the the
crucible of post-war Britain.
Her early years, which fell right
between the end of World War II
and the flourishing counterculture
of the sixties, found Westwood
surrounded by monumental
societal and political change.

'I WAS BORN DURING THE WAR AND GREW UP IN A TIME OF RATIONING. WE DIDN'T HAVE ANYTHING. IT'S INFLUENCED THE WAY I LOOK AT THE WORLD.'

During her early years, rationing was still in place and the economic situation in Britain was unstable, to say the least. Gordon Swire, Vivienne's father, was a storekeeper in an aircraft factory, a job that arose out of wartime necessity. It was a job that kept the family housed and clothed, but didn't offer much in the way of excess. Vivienne's working-class upbringing instilling in her a sense of resourcefulness and pragmatism, which – when combined with her burgeoning artistic yearning – meant that from an early age she was the kind of person who liked to make things. She made her own jewellery, knitwear, or would take something old and make it brand new. She was an ideas person, yes, but she could turn her ideas into reality. And her mother, Dora, nurtured this creativity, encouraging her interests in the arts, music and theatre.

Education after the war was changing. The 1944 Education Act assured the people of Britain that there would be better access to secondary education, namely for women. Despite this, for a working-class young woman like Westwood, higher education remained a somewhat hidden path. After her family moved to Harrow in northwest London in 1958, she enrolled in a jewellery and silver-smithing course at Harrow Art School – a commitment to her artistic expression. And yet, as is so often the case for those who haven't grown up with the privilege of access to education, self-doubt prevailed and she left the course after just one term. She said, famously, some years later: 'I didn't know how a working-class girl like me could possibly make a living in the art world.' But, evidently, all was not lost. The experience sat deeply with Westwood, and that feeling of being an outsider in the worlds of creativity and art would go on to influence her later defiance against the elitism of fashion.

But, before all this, she became a primary school teacher. A reasonable role and one in which it's doubtless she would have excelled. However, her need to create was unshakeable. During her stint as a teacher she continued to hone her craft in jewellery making, creating pieces she would sell at a market stall on Portobello Road in London. She was both talented and industrious.

In 1962, at the age of 21, she married factory worker Derek Westwood. Of course, she made her own wedding dress (in design, perhaps a little different to Carrie Bradshaw's ill-fated wedding gown, which was created by Westwood many years later, but a foreboding detail nonetheless). A year later she gave birth to their son, Benjamin. At the tail end of the fifties it seemed as though Westwood had taken the completely expected path into marriage, motherhood and the typically female role of early years' teacher. Yet the stirrings of the sixties era – with its emphasis on societal change and personal expression – was calling to her.

It was a time of Mary Quant miniskirts, Carnaby Street and a burgeoning rock and roll scene, all set against a backdrop of the faltering post-war economic boom, massive labour unrest and a growing sense of disillusionment with the establishment in Britain. People were rejecting traditional values and embracing a rebellious spirit. Of course, this turn in the tide spoke to Westwood. She, like many others, began to see through the rigid social hierarchy and unfair limitations placed on women. Combine that with a growing sense of economic disparity, and the seeds of Westwood's future political activism were sown here, in her formative years.

By now, she was customising her own outfits, incorporating vintage finds with tailoring to reflect her growing creativity. It wasn't really about aesthetics – it was about finding ways to assert her identity and challenge conformity.

By the time Vivienne met art student Malcolm McLaren in the mid-sixties, having already split from Derek Westwood because of a want for different things, the fuse was lit for a revolutionary meeting of minds. Her talent, her deep sense of injustice and her experience of creating in a world full of limitations coalesced, and McLaren's big vision and entrepreneurial nature provided the perfect catalyst for their joint explosion. With their outrageous creations, powerful ability to speak up against the ills of the systems that ruled, and talent for create things of real beauty, their collaboration would be so seismic that it would forever change the landscape of fashion and culture.

'I DIDN'T KNOW HOW
A WORKING-CLASS GIRL
LIKE ME COULD POSSIBLY
MAKE A LIVING IN THE
ART WORLD.'

Chapter 2

VIVIENNE, Meet MALCOLM

London, 1965. Vibrating with energy, the city was unlike anywhere else in the world – most particularly unlike Glossop, the provincial industrial town where Westwood had grown up. Her family had moved to Harrow a few years earlier, and she then left the family home to live with her first husband in the same area. Things were not going well. She said: 'We were living the American dream, but the dream ended with me in the kitchen,' and so she left him – to 'fulfil her potential'. At the age of 24, she packed up her bags and her dreams, leaving Harrow and her husband, and moved to Oval in South London, where the city was far more alive with possibility.

Across town, Malcolm McLaren, a firebrand for revolutionary politics, had his feet firmly placed in the growing avant-garde art scene. He had already explored filmmaking and situationist theory and, although he didn't know it, he was looking for a collaborator. And he met Vivienne. But their worlds didn't collide in some perfect artistic 'meet cute'. They met, so it's said, in the most mundane of places: a shop.

The precise details of their first meeting remain cloaked in punk rock mystery. But many say it was at a Letts shop – a chain known for its affordable clothes, where Vivienne, with her artistic eye, was searching for fabrics. Westwood was already a skilled jewellery maker and budding fashion designer and she was drawn to McLaren's intellectual energy and rebellious spirit. She'd already started crafting unique clothing, drawing inspiration from her keen eye for vintage, before tailoring it to reflect the rebellious edge of the times. Malcolm saw the potential in her designs, as a means to visually manifest the deep anti-establishment sentiments brewing within them both.

'HE INFLUENCED THE WAY I DRESSED AND THOUGHT ABOUT CLOTHES TOO. HE BEGAN TO SPEND MOST OF HIS STUDENT GRANT ON CLOTHES FOR ME. HE CARED PASSIONATELY FOR CLOTHES AND TRANSFORMED ME FROM A DOLLY BIRD INTO A CHIC, CONFIDENT DRESSER.'

Their early years together were a whirlwind – full of shared passions and creative explorations. Malcolm and Vivienne moved in together, into a flat above a furniture shop. In 1967 they had their only child together – Westwood's second son – Joseph Corré, who would go on to found global lingerie brand Agent Provocateur in 1994. The flat was cramped with the three of them, but that proved to be a perfect melting pot for their big ideas. Vivienne called on her artistic background, experimenting with cutting and remaking clothes in order to question and subvert classic silhouettes. Malcolm theorised and challenged Vivienne – spurred on by the energy from the anti-Vietnam War protests and his growing dedication to the situationist cause – a Marxism-based movement of avant-garde artists across the world, who felt the West's growing obsession with individualism would have harrowing affects on humanity. They believed image, what we wear and how we consume, could be essential tools for resisting this growing obsession with the self and the acquisition of goods to furnish it. McLaren saw clothing as a weapon – and Westwood was a sword maker.

Their collaboration didn't just stay at home, of course, and London in the late sixties was the site of the world's most thrilling youth-quake. Hippiedom was on the rise, but Westwood and McLaren found the movement isolating and middle class. Instead, as Westwood would so often go on to do, they looked back – to the fifties, to the the fashions and rock music of the Teddy Boys. Clean lines, geometric prints, androgynous silhouettes – these were the staples of the style, which slowly began to give way to a subversive aesthetic, one that Vivienne and Malcolm were drawn to. At 430 King's Road, in the back room of a shop called Paradise Garage, McLaren started to sell his vast collection of rock 'n' roll records and Vivienne started to make Teddy Boy clothes for him. Bands such as The Who and The Kinks were leading the charge of British Invasion rock – their music questioning the established order. These influences became obsessions for Vivienne and Malcolm, fuelling their want to disrupt fashion, too. And so they named their small stall on Chelsea's King's Road 'Let It Rock'.

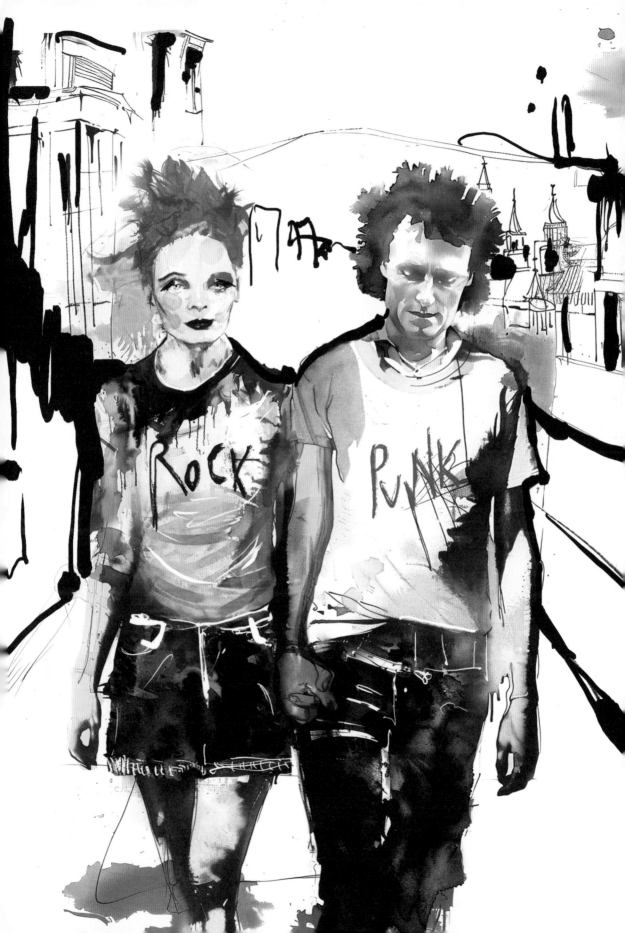

When Vivienne and Malcolm opened Let It Rock, it became a cry to challenge the status quo. The contents of the shop were testament to this. Gone were the polished displays associated with traditional boutiques; instead, the clothes were thrown on racks, music blared – a mix of punk rock and anti-establishment anthems – all creating a deliberately chaotic atmosphere. Let It Rock wasn't just a shop: it was a manifesto, a space where the disenfranchised youth of London could find a home and a way to express themselves, helmed by the driven creative couple that was Vivienne and Malcolm.

Vivienne started to incorporate elements of fetish and biker wear into her designs: another nod to the emerging countercultures. Malcolm, naturally provocative, loved this rebellion. He saw the power of shock and found clothing a brilliant place to start. Their early creations were far away from the polished, well-cut, high fashion that Westwood would later become known for. The early designs were raw, subversive, humorous. From Teddy Boy-style to increasingly sexual and subversive pieces, their innovation and need to disrupt made them the aesthetic architects of the movement that would come to be known as 'punk'. From safety pins to bondage trousers, bone-embroidered T-shirts and jackets adorned with provocative political slogans, these were entirely new ideas.

They pushed each other for a long time, eventually breaking out of the punk scene to hit big in fashion (much more on that to come). However, slowly but surely, their relationship and partnership ended, officially in 1984. When McLaren died in 2010, Westwood led the tributes to her former partner, but not long after she revealed that he had treated her and their son, Joseph, with much contempt over the years, with great jealousy of the success of her business. 'Although Malcolm had been so very awful to me,' Westwood said in 2012, of his death, 'and I've nothing to love him for, I was very upset by the news. I still felt some sort of loyalty to him. I shouldn't have, but I did.'

'THERE WAS NO
PUNK BEFORE
ME AND MALCOLM.'

Chapter 3

MOTHER

of PUNK

Today, the word 'punk' naturally conjures up images of fashion: safety pins, ripped clothes, slogan tees and brightly-coloured spiked hair. But punk was a political movement – its style, its music and its scene a mere (brilliant) symptom of a society gone wrong, and a youth with a need to reject it.

'IT'S TRUE THE PUNK FASHION ITSELF WAS ICONOGRAPHIC: RIPS AND DIRT, SAFETY PINS, ZIPS, SLOGANS, AND HAIRSTYLES. THESE MOTIFS WERE SO ICONIC IN THEMSELVES — MOTIFS OF REBELLION.'

In the early seventies, Britain's economy was stagnating, and there was a deep, growing social tension. The working class were neglected, the youth ignored and the government both ineffective and unresponsive. Punks took umbrage against the establishment – government, the royals, even the music industry – and raised a middle finger to its corruption, and the way it stifled expression and creativity. They sought authenticity and autonomy, and a place to let out their anger. The cultural explosion of mid-seventies Britain was an aggressive rejection of the emptiness of the mainstream and the failure of politicians. Of course, every army needs a uniform, and Westwood became the chosen designer of this disenfranchised youth.

Because so much of punk was about both the clothes and the music, about disrupting spaces with looks and with noise, Westwood and McLaren were at the vanguard of the punk movement. Their ideas became instantly iconic – portraits of the Queen pierced with safety pins printed across T-shirts; bondage straps winding around trousers. These things had never been done before, and Westwood had a nose for new ideas.

'IT'S A PHILOSOPHY OF LIFE.
A PRACTICE. IF YOU DO THIS,
SOMETHING WILL CHANGE,
WHAT WILL CHANGE IS THAT
YOU WILL CHANGE, YOUR LIFE
WILL CHANGE, AND IF YOU
CAN CHANGE YOU, YOU CAN
PERHAPS CHANGE THE WORLD.'

Music was equally important to the movement, and that music was loud, raw and fast. The Ramones, the Sex Pistols and The Clash epitomised the sound, with their aggressive guitars, screamed vocals and lyrics about rebellion and corruption. The music and the lyrics critiqued and questioned social norms: *why are things this way?* But punks – like any decent music subculture – weren't just listening to this angry music, they were living it. And clothes were part of the language.

So, Westwood and McLaren's King's Road boutique, now renamed SEX, became the epicentre of the punk-quake that shook the world. Hippies, with their free-flowing florals, were out – ineffective – and now clothes became an assault on the senses. Slogans were direct, rips were big and safety pins held everything together. Bondage wear and torn fishnet stockings were the perfect base for any punk outfit. No rules, except one: reject conformity and celebrate the expression of your rage against The Man. There were no trends and there was certainly no need to own a full Westwood look, head to toe. In fact, punks revelled in DIY: customising clothing, adding studs, patches, chains, or pinning pictures of their favourite bands to their outfits. Hair was dyed in garish colours, and the whole outfit was meant to shock: a visual manifesto to confront anyone who encountered the punks.

'WHAT I DO NOW IS STILL PUNK – IT'S STILL ABOUT SHOUTING ABOUT INJUSTICE AND MAKING PEOPLE THINK ... I'LL ALWAYS BE PUNK IN THAT SENSE.'

They weren't welcome in mainstream places, because so often gigs and parties ended in furious brawls and police raids. This was a scene full of energy and fight, one that created its own spaces to be and places to go. Westwood and McLaren's shop was one of them.

But, like anything with such fervour, punk was a short-lived movement. Once the early eighties rolled around, the initial shock value had worn off and punk had become a fashion statement more than a political one. Even Westwood, one of its progenitors, had grown tired of it. The mainstream began to co-opt the punk aesthetic, as it so often does with anything on the fringes, watering down its rebellious essence. In the end, many felt the movement had lost its authenticity.

Westwood, however, transcended the frontiers of punk and, while these early moments in her design life remain some of her most formative and iconic, she continued to push and push at the boundaries throughout her whole career. She would go on to become a highly highly respected – even idolised – designer, influencing generations to come with her use of fabric, her fascination with history, and her ability to design for the future. But punk is where it began. She created a cultural phenomenon that was not about what clothes you wore, but rather about what those clothes *meant*. Clothes were a means to express, to protest, to protect, to project. She asked more of clothes, and in the answers she discovered great power and great meaning.

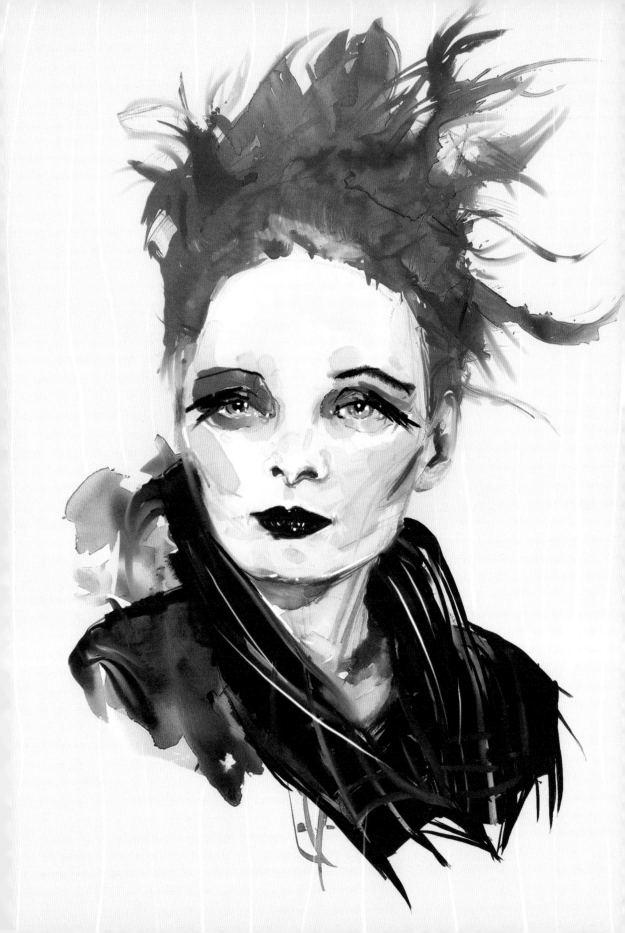

Chapter 4

From
CURATOR
to
CREATOR

Vivienne Westwood's design journey
didn't begin with a sketchpad and
fabric swatches, but with a bored,
disillusioned shopkeeper. She was
growing tired of the trends of the late
sixties – the flowing silhouettes and
all that flower power felt completely
at odds with her rebellious spirit.
It was 1971. The King's Road in
Chelsea pulsed with the fading beat
of the hippie era and a new rhythm
was about to take hold – starting
at number 430. This unassuming
address would become the epicentre
of a quake that would redefine
the rhythm of youth culture, and
eventually wider society. It was the
address of Westwood and McLaren's
first boutique: Let It Rock.

'EVEN THOUGH IT WAS THE SEVENTIES, WE FOUND OLD STOCKS OF CLOTHES THAT HAD NEVER BEEN WORN FROM THE FIFTIES AND TOOK THEM APART. I STARTED TO TEACH MYSELF HOW TO MAKE CLOTHES FROM THAT KIND OF FORMULA.'

The site was initially home to Paradise Garage — a well-known shop that specialised in used denim. It was owned by Trevor Myles and, in 1971, he rented a tiny sliver of space to McLaren and Westwood, who was still teaching at the time. Their initial focus was rock 'n' roll paraphernalia, records and second-hand clothing — particularly the faded glory of denim and Osh Kosh B'gosh dungarees.

Success came swiftly and, by November of that year, they took over the entire lease from Paradise Garage. The transformation was dramatic. The corrugated iron facade was slicked with black paint and emblazoned with the name — Let It Rock — in bubblegum pink lettering. The name was a nod to the Chuck Berry rock anthem, but also to the ethos of Westwood and McLaren's collaboration. Inside the vibe changed: once a cluttered market place, it was now a meticulously curated fifties-style living room. Odeon wallpaper covered the walls, Festival of Britain trinkets sat on the shelves, and a jukebox pumped out classic rock — setting the scene for the sartorial rebellion.

Westwood and McLaren were at this time obsessed by the Teddy Boy subculture, a post-war British movement characterised by Edwardian-inspired clothing with a rebellious twist. Let It Rock brimmed with brothel creepers (the ultimate crêpe-soled platform shoes), zoot suits (wide-legged trousers with a high waist and a jacket with wide lapels and padded shoulders) and velvet jackets immaculately tailored by Sid Green, an East End tailor.

The clientele at Let It Rock wasn't the usual fashion crowd. Young artists, musicians and those yearning for something new gravitated there. Bands such as The Who and the Sex Pistols were early adopters, drawn to the unique clothes and anti-establishment spirit that filled the air at the boutique.

They might have started off selling vintage pieces, but Westwood's creative spirit couldn't be contained for long and she began designing her own garments, imbued with youthful energy. She often started with existing pieces: imagine a classic Teddy Boy jacket ripped apart and safety-pinned back together, or a pair of jeans appliquéd with provocative messages. These designs set the stage for Westwood and her signature aesthetic: one that rebelled against the conformity of mainstream fashion. Just as she did with the suits, she tore things up and reimagined how they might be put back together.

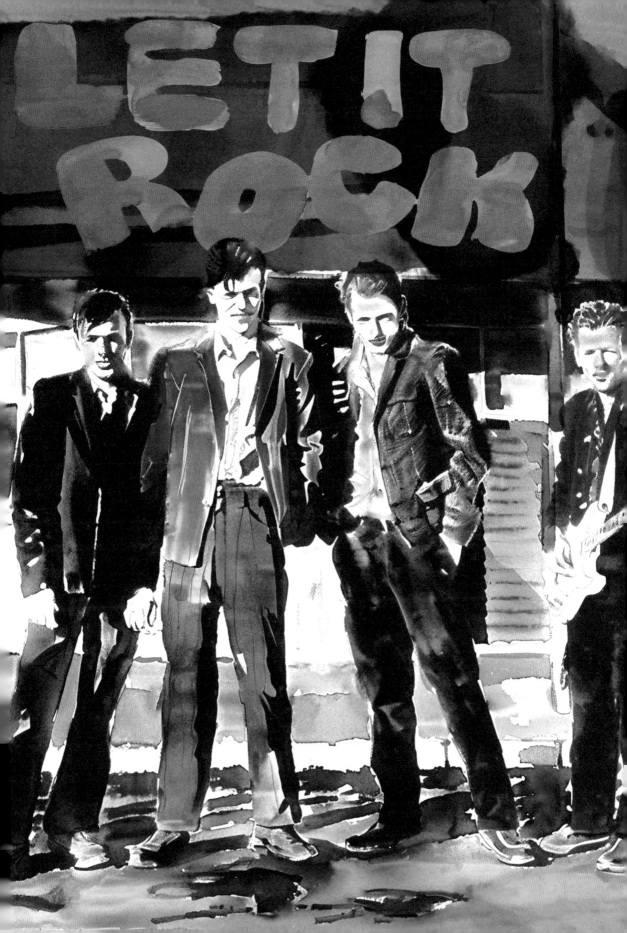

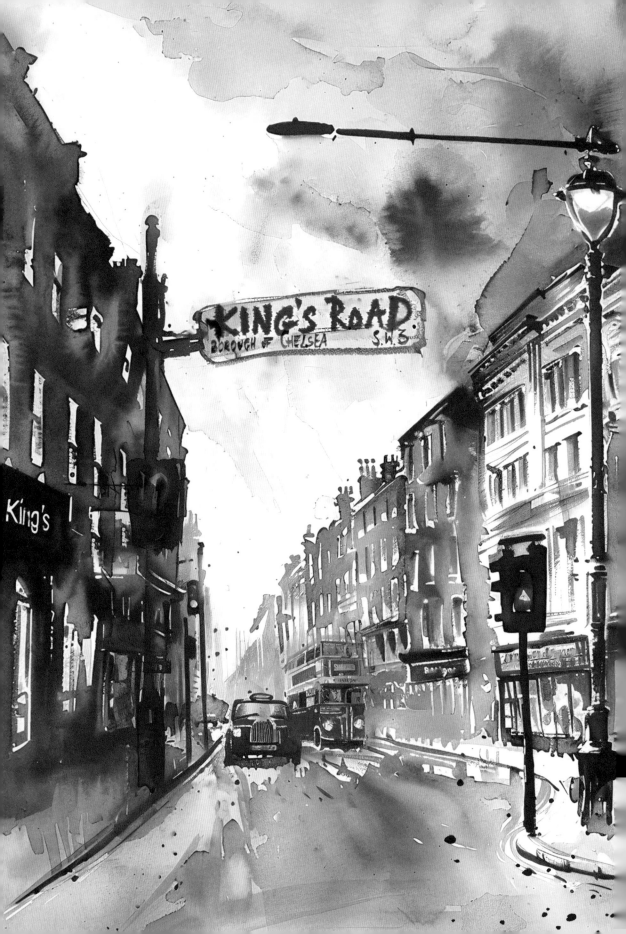

'THERE'S NOWHERE
ELSE LIKE LONDON.
NOTHING AT ALL,
ANYWHERE.'

Initially, neither the press nor the mainstream were drawn to this tiny shop in Chelsea. But seeds were being sown. Local publications started to take notice, intrigued by this brand new vibe at the end of the King's Road, and the couple behind it. John Stephens, London tastemaker and a boutique owner himself, became a champion of their work and his patronage pushed their names to his influential circle. And so Let It Rock began to rock indeed.

Reflecting on Let It Rock in an interview in 2004, Westwood said: 'The clothes were about a rejection of the polite society and everything that went with it.' But, as with anything new, it didn't stay the same for long. By 1972, Westwood and McLaren's vision transformed into something else. They renamed the boutique Too Fast To Live, Too Young To Die, which mirrored their shift in a new direction, towards a more confrontational aesthetic.

While legendary, the clothes of Let It Rock weren't entirely Vivienne's own. Inspired by Malcolm McLaren's commitment to the Teddy Boy subculture, Westwood began by editing clothes that harkened back to this era. Edwardian jackets were cinched; bold tartans became waistcoats and shirts. These garments weren't replicas: they were originals because Westwood took what was there and subverted it. In 1972 her aesthetic sensibilities began to evolve and Teddy Boys were replaced by an obsession with biker culture. Leather lay at the heart of Westwood's offering at this time. Jackets were studded, zips were everywhere, trousers were made from sleek black leather — a new sexuality and rebellion permeated the collection.

'YOU HAVE A MORE
INTERESTING LIFE
IF YOU WEAR
IMPRESSIVE CLOTHES.'

The shift wasn't merely aesthetic – it mirrored, and in many ways defined, the growing punk movement in London. Westwood and McLaren were now becoming drawn to the raw energy of punk, and the shop began attracting clients who embodied this anarchic spirit. Musicians such as Siouxsie Sioux and members of the Sex Pistols, who were soon to become icons of the punk movement, frequented the shop, further tying Westwood and McLaren to the iconic subculture.

By 1974, Westwood was navigating another turning point in her design trajectory, and so the shop underwent another rebranding, this time to its most infamous configuration: SEX. This period – referred to as her 'SEX phase' – saw the realisation of the most recognisable signatures in her early design vocabulary. Now totally embracing the confrontational spirit of punk, Westwood and McLaren emblazoned T-shirts with slogans such as 'DESTROY' and 'Anarchy in the UK'. These quickly became the uniform of the punk movement, and its anti-establishment stance. Clothes were torn, safety pins became both deliberate and necessary, and bondage pants challenged ideas of both modesty and practicality.

But she wasn't creating for mere shock value. Westwood really believed in bringing the hidden out into the open – and that doing so could inspire some kind of freedom. She was incorporating elements of bondage and fetishwear into her clothes to make statements about power dynamics between the wearer and the state, as well as to question gender roles. Rubber and PVC became outerwear; conceal and reveal became a language. And boundaries became blurred. The SEX boutique was legendary: a manifesto for the punks and the youth of the day to keep on pushing boundaries. Their slogan at this time, famously, was 'rubberwear for the office'.

'POPULAR CULTURE IS A CONTRADICTION IN TERMS. IF IT'S POPULAR, IT'S NOT CULTURE.'

At SEX it wasn't just clothes that were for sale – Westwood and McLaren were crafting an identity. In 1975, with his keen eye for disruption, McLaren became co-manager of the Sex Pistols – a band already known for their aggression, and as a thorn in the side of the establishment. Johnny Rotten and Sid Vicious became living advertisements for Westwood's creations and together they raised an alchemical battle cry against conformity.

Tales of the band and the shop are deeply intertwined. One anecdote details a young Johnny Rotten with his long green-dyed hair walking into SEX, and there meeting an unimpressed Westwood. She grabbed a pair of scissors and cut his hair into a short, spiky mess – a style that became totemic of punk. McLaren saw this as the perfect visual identity for the band he was managing. Sid Vicious, the bassist, became the true embodiment of punk's nihilistic tendency. His antics on stage – amplified by drugs and booze – became legendary. At one gig that Westwood attended, Vicious spat at a fan, the fan spat back, and a giant brawl broke out.

SEX became a meeting point for the young and the disaffected. People flocked there: drawn to the music, the clothes and the sense of finding a community who wanted something better from the world, who were angry at the system. It became a place where they could express themselves, away from the limitations and conservatism of mainstream society. The police frequently raided SEX, simply adding to the allure of the forbidden.

Perhaps the boutique's most (in)famous moment wasn't the launch of a new T-shirt or a live band performance. It was the Queen's Silver Jubilee in 1977. In May that year the Sex Pistols released 'God Save The Queen', a deeply damning indictment of the monarchy. The cover art for the single, designed by graphic designer Jamie Reid, depicted torn cut-out lettering pasted over the Queen's face, and it perfectly captured the band's rebellious spirit. It caused national outrage, pushing punk into the mainstream. Westwood simultaneously created a T-shirt showing the Queen with a safety pin through her nose and the lyrics from the song surrounding the image. Wearable rebellion. From here, Westwood gained the platform that brought her influence to generations of artists, musicians and anyone who dared to be different. The boutique – by now renamed Seditionaries – might just have been a shop on the King's Road, but it was also the spark that ignited a cultural revolution.

By now, the boutique had moved into a new phase. The name Seditionaries, which means 'people who incite rebellion against the state or the monarch', solidified the political nature of Westwood and McLaren's message. The designs, of course, maintained their subversive streak, incorporating bondage elements such as harnesses and chains, or a swastika reconfigured to represent consumerism. But a shift had started and, although her controversial spirit remained, a focus on tailoring and cut began to enter Westwood's design lexicon. She started experimenting with corsetry, with cinched waists and exaggerated curves. This push and pull at the traditional feminine silhouette would go on to become a real signature of Westwood's later design work.

'AT ONE TIME, I WAS VERY ANGRY. I EVEN TREATED FASHION LIKE A KIND OF CRUSADE: YOU WERE EITHER WITH US OR AGAINST US, THAT KIND OF FEELING. NOW I KNOW WE NEED IDEAS, NOT KICKING DOWN A DOOR.'

In 1980 this shift would cause the pair to rename the shop once again, drawing inspiration from its Chelsea location. Now it became Worlds End, a name that would stick, and which is still the name of many Westwood boutiques around the world today. When Westwood and McLaren split as a couple, the shop closed temporarily in 1984 – only to reopen in 1986 with Westwood alone at the helm. This era saw the end of Westwood's professional partnership with McLaren and she began to forge her own path. Yet the foundations laid during their time together were unshakeable. The spirit of rebellion, her need to subvert, and her desire to challenge social norms started here as the threads that would be woven through Westwood's entire illustrious life as a designer.

SAFETY PINS

In her early work, Westwood found a potent symbol in the humble, useful, razor-sharp safety pin. More than just a fastener, the pin became her weaponised adornment – a form of rebellion piercing the fabric. She pulled things apart and put them back together in a way that seemed befitting of the broken establishment that she, along with Malcolm and the punks, was railing against. Anything to reject beauty and propriety.

The safety pin embodied this spirit perfectly. It was cheap, available and inherently utilitarian. Yet, in Westwood's hands it transcended its practical nature. The pins became visible seams and closures – holding fabric together, pinning slogans across garments – in ways that felt simultaneously destructive and brilliantly reconstructive. This was punk saying: 'Here we do it ourselves. Here there's no such thing as polished perfection.'

The pins pierced the Queen's image on T-shirts, once again using Westwood's design genius to decry the monarchy. They secured her torn tartans and her bondage wear. The humble safety pin – a usually innocuous object – became a weapon of expression, a visual challenge, that was arguably holding together a culture built on deconstruction.

As a symbol, it stayed with her throughout her life in design, transcending her early styles and serving as a constant reminder of her punk roots. Even today, the safety pin remains a totem of rebellion, a signal that clothes are a means with which to challenge civility ... with a sharp prick.

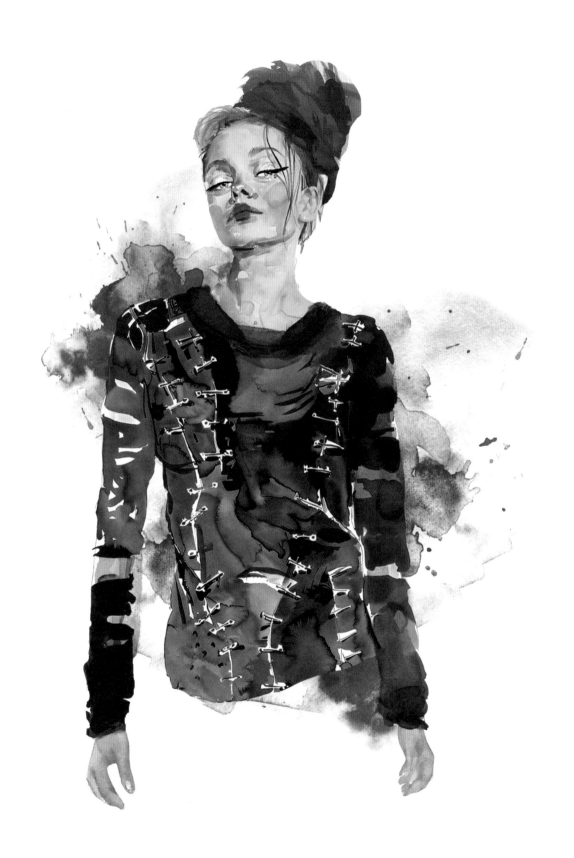

T-SHIRTS

In Westwood's world, the humble, democratic T-shirt was transformed from blankness into a billboard for her and McLaren's discontent. Their shop, in all its forms, was ground zero for punk fashion and Westwood drew many fans with their shared message – often communicated using a powerful slogan. They took this often conformist garment and emblazoned it with messages that challenged the norm. 'DESTROY' and 'God Save The Queen' were much more than fashion statements: they were sharp critiques of a system that the punk movement found hypocritical.

Queen Elizabeth II – a symbol of tradition and injustice for the punk movement – became a target for Westwood , who pinned her slogan-covered image to T-shirts. These weren't empty gestures. In 1977, when their God Save The Queen tee first landed, featuring the monarch with a safety pin though her lip, it was a big deal to criticise the royal family. Westwood and McLaren ended up in court on obscenity charges. Of course, Westwood adored the infamy and the trial became a means through which to amplify her anti-establishment fury. One of her most famous tees cried out 'There Is No Future'. Westwood designed not only clothes, but a conversation.

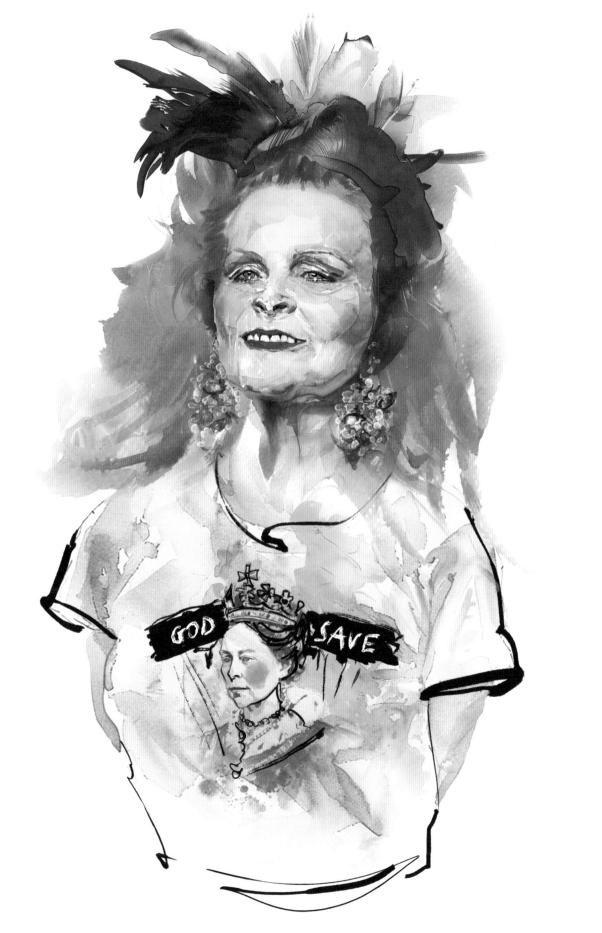

TARTAN

Tartan remains a staple of Westwood's design handwriting even to this day, but her relationship with it began at the very start of her career. The woven plaid fabric, usually associated with Scottish traditionalism, offered yet another route for subversion. She tore it from its expected context – one contemporarily reserved for formal wear – and transformed it into a symbol of youthful defiance and gender diversion.

T-shirts were an American staple. By adorning them with tartan, she twisted expectations once again. Today these ideas might seem old hat, but in the late seventies the world had never seen such clothes.

Her genius wasn't only in the fabric, but also in the message. She chose tartans associated with different Scottish clans, and these were now claimed by the punks to represent their own tribes. This was a new uniform for outsiders: a means by which to declare their allegiance to a movement that rejected the status quo.

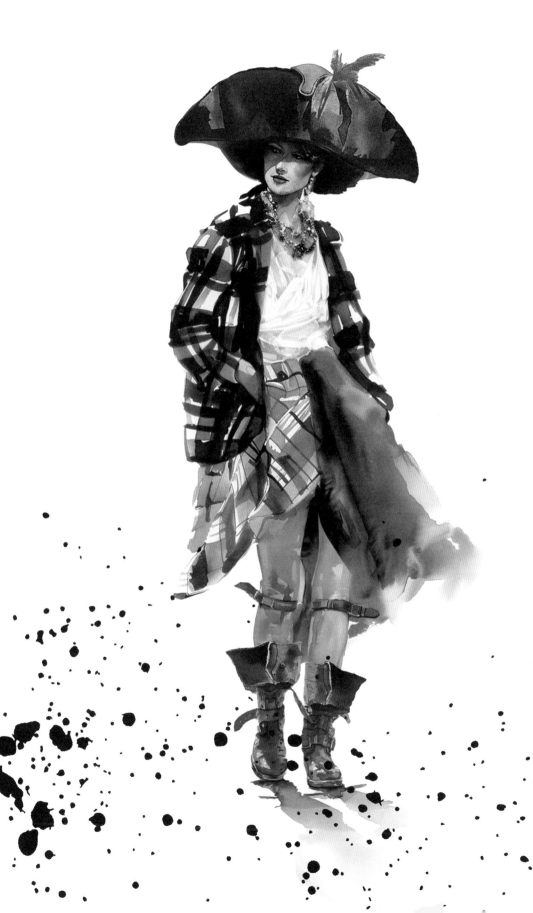

BONES

Perhaps Westwood's most controversial material, bar her reproducing of the Queen's image, was the use of animal bones in her designs. Instilling her works with a sort of primal rawness, these bones represented a rebuilding – something strong, structural and discarded was made decorative and useful once more.

Westwood used bones in various ways. Safety pins were attached to the ends of ribs, hanging off clothes and necklaces. Dog collars were decorated with animal vertebrae – a hint of the macabre that heralded a spineless society, as well as the end of days as we knew it. Skulls were frequently incorporated into belts or found hanging off zippers. And, while nothing to be scared of, the image created was one of danger, fearlessness and transgression. Westwood wanted to transgress the polished luxe of mainstream fashion and challenge accepted ideas of taste.

Being Westwood, of course, these bones sparked debate about animal cruelty – even though she claimed to use only bones she had found or foraged. But the shock factor was central to punk's message: get people talking. Westwood asked why couldn't bones be used on clothing? She certainly couldn't find a good reason why not.

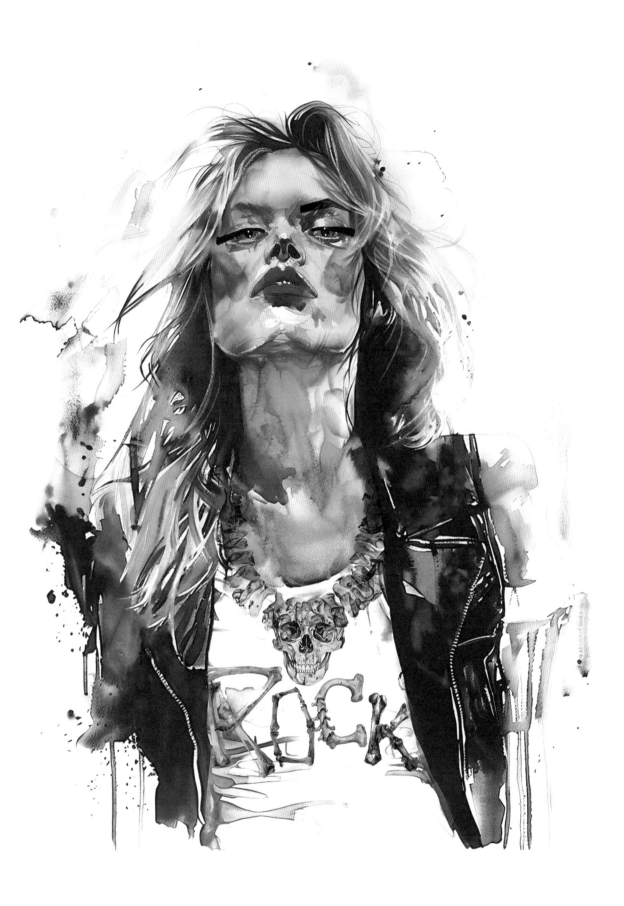

Chapter 5
ICONIC
COLLECTIONS
The 1980s

Over the course of the eighties,
things began to change for Vivienne
Westwood. Disillusioned with
punk and how debarbed the once
radical movement had become,
Westwood ended the decade in a
very different place to where she
started it. She had moved from being
an outsider artist, famous for her
streetwear provocations, to a high-
end designer who was shaking up
the fashion industry. Whether this
was intended is difficult to analyse,
but, as Westwood's work changed,
so did her clientele. People always
wanted the next big thing – the most
chic, most cool, most beautiful thing
– and Westwood always delivered.
She became one of the most coveted
fashion designers of the age.

'MY AIM IS TO MAKE THE POOR LOOK RICH AND THE RICH LOOK POOR!'

Westwood started the decade by showing her first formal collection – with the legendary 'Pirate' show in 1981. Her collections of the first half of the decade would come to be dubbed 'New Romantic', while the second half of the decade she would call her 'pagan years'. The famous Westwood orb logo was unveiled in 1986, a symbol of carrying tradition into the future. In the same year that she reinvented the corset – 1989 – we saw Vivienne on the cover of *Tatler* dressed as Prime Minister Margaret Thatcher. So much had changed. And change was something Westwood relished.

Perhaps the most significant change in Westwood's work came in 1984, when she and Malcolm McLaren split as creative partners. She temporarily closed the Worlds End shop on the King's Road and moved to Italy to continue work on collections with her new business partner, Carlo d'Amario, who later became CEO of her company. Her initial collections explored ideas of sportswear as high fashion, with fluoro macs and body stockings, triple-tongued trainers and hip-hop influences. But the latter half of the decade saw a new aesthetic emerge – a singular vision, which many hailed as more structured and yet more feminine. Westwood had met Gary Ness, a Canadian painter and philosophy teacher, who encouraged her to learn more about history, literature and art. She would take him for dinner at Khan's Curry House in Paddington and he would tell her about elitism and the philosophy of Ancient Greece. Eventually, this growing fascination found its way into her designs. The fabrics were traditional and the references reflected Westwood's growing historical obsessions and discoveries. It was these cuts and creations that led to Westwood being named British Designer of the Year in both 1990 and 1991, ending the eighties as the most respected fashion designer of the time ... perhaps, we could say, of all time.

PIRATE

Punk had exploded onto the world stage – an explosion certainly detonated by Westwood and McLaren – and by 1981 it had reached its zenith. Yet those at the forefront could feel its power waning. The streets of London — once the epicentre of torn-tartan anarchy and safety-pin-covered protest — were beginning to calm. Of course, on Westwood's horizon, there was a storm brewing: a new, vibrant muse was emerging ... named 'pirate'.

Arguably one of Westwood's most important collections, 'Pirate' was a declaration that something new was coming. Although McLaren was still by her side at this point, it heralded the beginning of the end of their collaboration – and, naturally, punk. 'Punk had become a fashion statement,' Westwood told *The Guardian* in 2000. 'We had to go somewhere else.'

Judy Blame, legendary London stylist and one of Westwood's long-time collaborators recalled the collection in vivid detail. 'There were rich velvets, gold lamés, and these incredible squiggle prints,' he noted referring to the Westwood motif resembling electrical currents, which remains iconic today. 'Pirate'

was a treasure trove of beautiful fabrics and prints. The clothes, according to Blame, 'were a total departure from the safety pins and bondage trousers of punk'.

It was Westwood in a new era, with hints of her design handwriting running throughout, and ripe with historical references from the eighteenth and nineteenth centuries. Jodhpurs with draped backs were reminiscent of swashbuckling pirates. Electric bright waistcoats and asymmetric shirts invoked the flamboyance of highwaymen. She was a total history buff, and for this collection she dove headfirst into the V&A Museum's archives. '['Pirate'] was intellectual,' she told *AnOther* magazine in 2010, something she seemed proud of in comparison to her and McLaren's previously street-inspired approach.

Perhaps one of the most legendary pieces to arrive with 'Pirate' were the pirate boots, which remain a staple of any Westwood fan's wardrobe today. These slouchy boots, buckled with multiple leather straps, were crafted from velvets and leathers. They were a far cry from the typical punk combat boot.

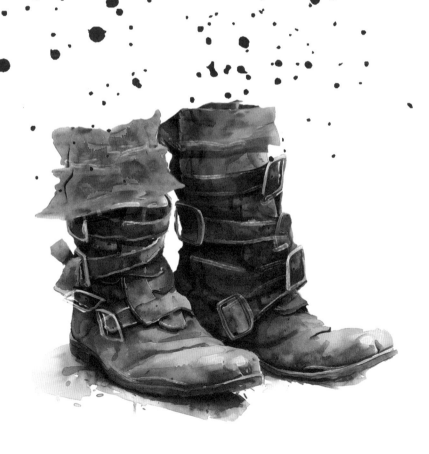

Gone were the stark white faces and heavily lined eyes that had been synonymous with punk. For 'Pirate', Westwood worked with make-up artist Georgina Bennett on gold teeth, gold nipples, and gold-lined lips. A thirst for gold. And the wearer, like a pirate made good, was regal and rebellious all at once.

And yet, despite the groundbreaking effect of the show, McLaren – always the agitator – felt the collection was straying a little too far from their punk vision. Westwood craved freedom – aesthetically and artistically – and so the cracks began to show in what had, up until then, been a genius (although not always harmonious) collaboration.

The impact of Westwood's 'Pirate' collection cannot be overstated. It signalled a move in culture: from nihilism to playtime, from punk to pirate. Yes, there was rebellion, but there was also theatre and history. It opened up a new visual language for a fashion-interested youth. 'Pirate was a turning point,' critic and journalist Suzy Menkes told *The Business of Fashion* in 2018. 'It put London on the map as a major fashion capital, proving it could rival Paris with its own unique voice.'

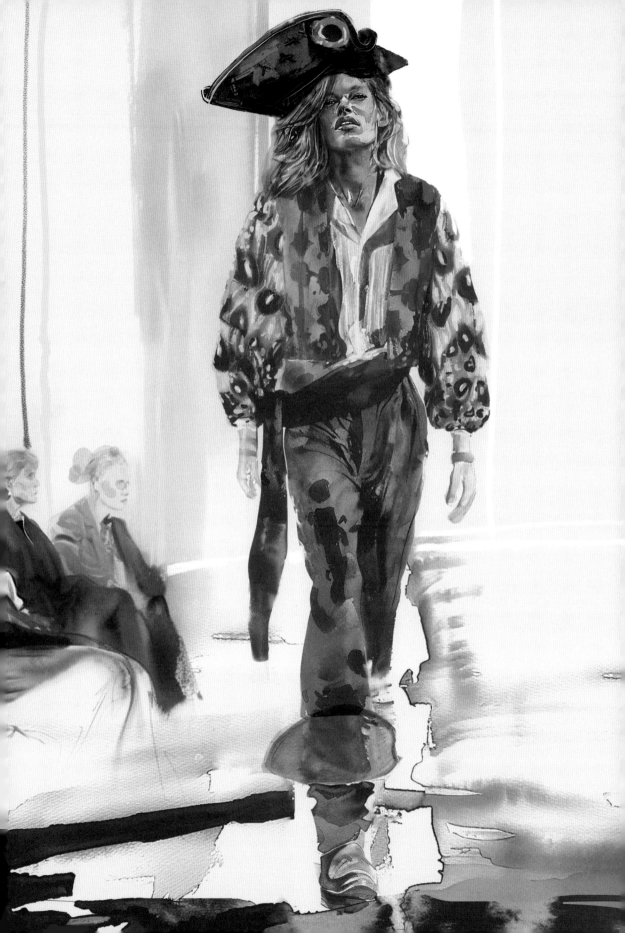

SAVAGE

SPRING/SUMMER 1982
WORLDS END LABEL

In the early 1980s Britain was held in a Conservative grasp. Margaret Thatcher had produced a disillusioned, restless youth who yearned for rebellion. And Westwood was looking to incite a fashion riot with her next collection. Unveiled in London in October 1981, 'Savage' was a primal scream against the establishment. 'We wanted to show the rawness of youth,' Westwood explained later. 'Untamed energy, the chaos simmering beneath the surface.' The sounds of Throbbing Gristle, a deeply fashionable industrial band, echoed off the walls. The whole event, once again, was so cool and pioneering that McLaren later described 'Savage' not as a fashion show, but as 'a happening'.

The garments mirrored the mood of the moment. As quickly as Westwood had adopted romance in her previous 'Pirate' collection, she now got rid of it. Garments were ripped and slashed, revealing glimpses of flesh. 'We were taking clothing apart, showing [...] its vulnerability,' Westwood said. The models were a motley crew of art students and punks, who tore down the catwalk in ripped fishnets and bondage trousers. Safety pins pierced almost everything – a DIY rebellion against the elite. Judy Blame did the make-up – 'war paint for the urban warrior', as he called it. Eyes were kohl-rimmed eyes; lips were black, green, purple and shocking pink; hair was spiked like daggers. Design legend Louise Gray recalls: 'It was a revelation. It felt like a middle finger to everything that fashion stood for.'

Ever the clever marketeer, marketer, McLaren coincided the show with the release of *See Jungle! See Jungle! Go Join Your Gang Yeah, City All Over! Go Ape Crazy!* — the debut album by Bow Wow Wow, a new wave band he was managing. The music had a raw energy and the band's teenage lead singer Annabella Lwin featured nude on both the album cover and the show's invite. Such scandal only only heightened the infamy of both the band and the collection.

Naturally, the mainstream press found it distasteful. But for the youth – the people Westwood was actually talking to – 'Savage' became another beloved turning point in fashion, one that is is still felt today. It was a moment that brought DIY ideas and construction to the traditional fashion runway.

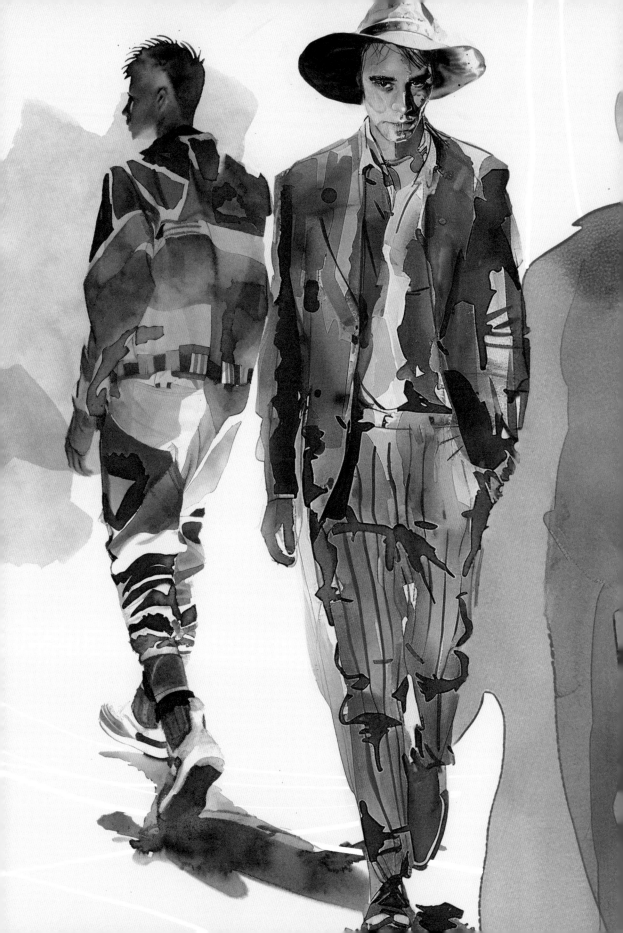

BUFFALO GIRLS (NOSTALGIA OF MUD)

AUTUMN/WINTER 1982–1983
WORLDS END LABEL

Now notorious for her punk provocations, Westwood was looking to push the boundaries even further. 'We wanted to get out of this island mentality,' she told *AnOther* magazine. 'To relate ourselves to taboos and magical things we believe we've lost.' She was done with the sterility of London and its power-suited streets. So, she made a collection that was a riot of colour and texture.

Mud-hued dresses in chocolate brown, rust and khaki were penetrated by elements of hot pink and ice blue. The silhouettes were built by layering, with hip-slung dirndl skirts worn atop big bouncy petticoats. Raw-cut sheepskin jackets hung over shoulders, while beautiful fine lace peeked through from undergarments and tops.

Westwood now had her keen eye trained on gender and wanted to challenge notions of femininity. Bras became outerwear, in satin fabrics and conical shapes. In fact, conical bras sat atop Grecian toga dresses, a design idea that pre-dated Jean Paul Gaultier's famed silhouette. 'Buffalo' would come to refer to the massive platform shoes that became synonymous with the collection. They towered, ready to stomp on traditional stilettos that had always been loved by the establishment. It was a symbol of breaking free from the shackles of traditional stiletto-wearing femininity. 'The Buffalo girls were a new tribe; they weren't concerned with looking pretty,' said Judy Blame. 'They were concerned with looking strong.'

The collection also ushered in a new age – the New Romantic era – which favoured androgyny, history and theatre. It was one of the many times Westwood rebelled against the fashion elite – and also against herself. Here, she'd made romance, not fury; she'd prioritised strength above anger. All are required to make an icon, but Westwood was exploring each one in different measure.

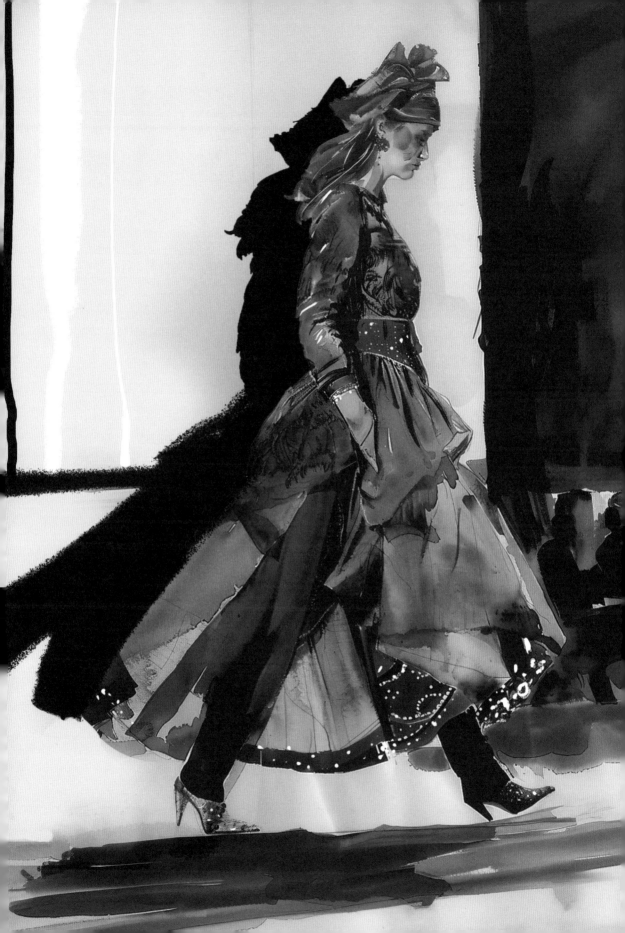

PUNKATURE

SPRING/SUMMER 1983
WORLDS END LABEL

While Westwood's name was starting to soar, her relationship with Malcolm McLaren was changing. She craved creative freedom, and he craved it too, so they began to go their separate ways – he towards music and she towards fashion. While the collections were still coming out under their joint name, this created a seismic shift in the way things were done at house Westwood, and her next collection was the chance to stake her own claim in fashion.

'It was a moment of change. I was finally able to find my own voice as a designer, separate from Malcolm's ideas,' she explained of this moment. Of course, 'Punkature' wasn't a complete break from her past – threads of Westwood's punk roots wove themselves through the collection as distressed fabrics and de- and re-constructed silhouettes.

'Handcrafted hillbilly' is how Westwood described the collection. Long tube skirts looked straight from the prairie in shape, but were made from cotton tubing normally used for automotive cleaning. Tattered skirts added whimsy, and garments were tie-dyed and flowing. Socks and sandals made an appearance – an ugly idea, made chic by Westwood. With references and inspiration drawn from the movie *Blade Runner*, the Napoleonic Empire and Brazillian favelas, Westwood continued her fascination with cultures far and cultures past.

'Punkature' is considered a key bridge between the outgoing punk movement and the incoming New Romantic movement. What's interesting is that these movements were born from deep interest and research, as much as they were about responding to the time. There was rebellion and reactivity, but also a growing ethos that, although fashion moves on quickly, ideas such as punk and New Romanticism must be developed slowly over time.

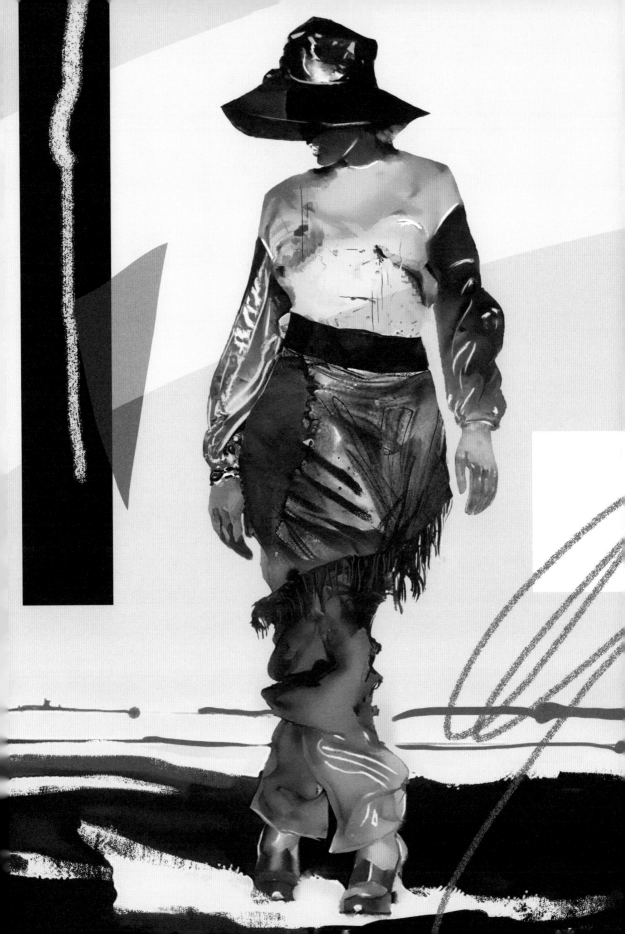

WITCHES

AUTUMN/WINTER 1983–1984
WORLDS END LABEL

At the beginning of 1983 Westwood took a trip to New York to meet visual artist Keith Haring, who was in the nascent stages of his career. Westwood was deeply inspired. His bold, graphic style, which highlighted figures adorned with magical symbols, drew Vivienne in. 'We were very interested in Haring's magical, esoteric sign language,' she recalled later: '['Witches'] was quite different from punk!'

Indeed, this was the beginning of Westwood's fascination with the occult in her designs. In this collection there were layered tartan skirt styled with giant, deconstructed jackets. Bodices were slashed across the waist, while fabric draped at the bust, or vice versa, revealing flashes of flesh. Tights were ripped, layered and ripped again, while pointed hats and oversized accessories added a touch of mysticism and theatrics.

The most famous piece from the collection is perhaps the grey wool dress that featured a bright Keith Haring print across the front. It was an ode to, and a lasting relic of, their artistic cross-pollination. But it wasn't a costume – it was about powerful feminine energy.

This was a pivotal moment in Westwood's life. Her personal and artistic relationship with McLaren was ending, and 'Witches' felt like a statement of individual power, related directly – and divinely – to the unconventional female.

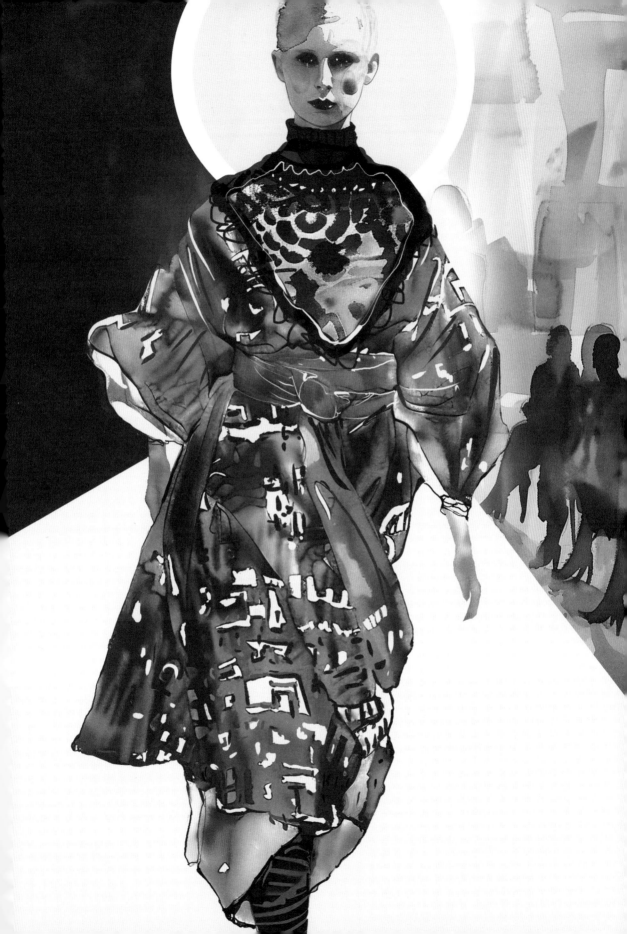

HYPNOS

SPRING/SUMMER 1984
WORLDS END LABEL

The year 1984 marked a turning point for Westwood. She had gained notoriety among the fashion set by now, and was known for reinvention, for statements, for boldness. She had split (romantically) from McLaren and punk seemed firmly over. Westwood, by this point, was certainly tired of it. She wanted something new – new cuts, new references. She made a new start by moving to Italy and showing her first ever solo collection in Tokyo.

'Hypnos', a dreamlike dystopia, was inspired by the Greek god of sleep, but also of sleeplessness. It was also inspired by London's gay scene and how its fashion style crossed over with the style of famous footballers. 'We were looking at a more surreal, psychological side of rebellion,' explained Christopher Nemeth, Westwood's collaborator at the time.

Clashing prints and textures, with subverted tailoring, hinted at the end of the world, a topic that constantly recurred for Westwood. One of the more famous pieces from 'Hypnos' was the 'extended T-shirt' – a long satin football-style T-shirt that was attached to an exposed jockstrap.

'Pale faces, dark circles and shimmering lips – like decadent, sleep-deprived aristocrats,' said make-up artist Judy Blame of the look. Westwood loved this collection and described it as 'a beautiful, post-apocalyptic world'.

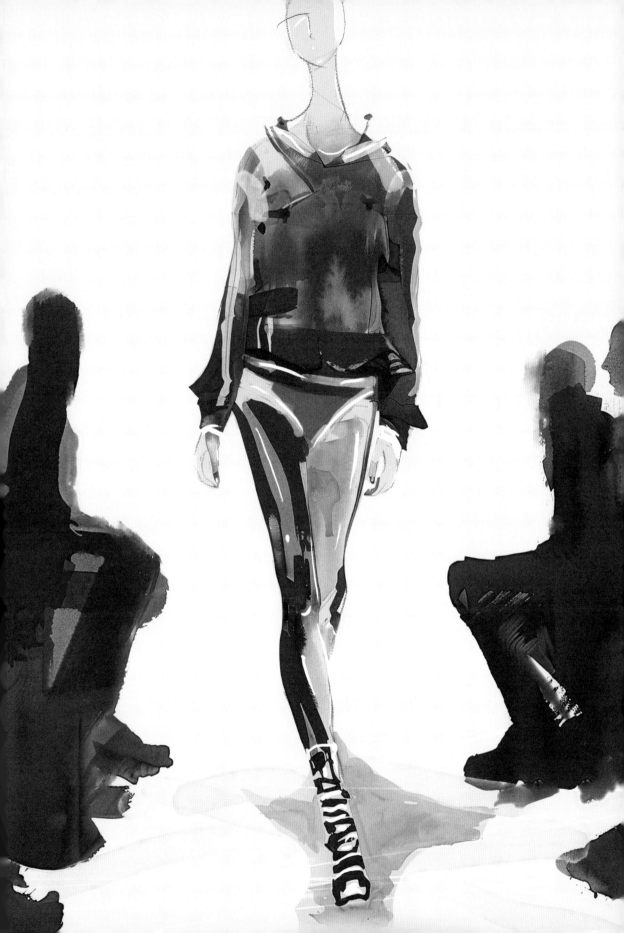

MINI-CRINI

SPRING/SUMMER 1986

With this collection – her first after officially parting ways with McLaren – Vivienne pushed her themes of critique and dystopia even further. She referred to the collection as one of 'cardinal change' for her now eponymous label. From here on she was more interested in clothes that fitted the body, with an increasing fascination in a deliberate study of historical dress and design.

Staged in an abandoned ballroom in Paris, the show's atmosphere was one of opulent decay. 'Vivienne wanted to show the decline of Western civilisation,' said hairstylist Stevie Stewart, who designed the hair for 'Mini-Crini'. Tartan jackets were cut asymmetrically and paired with voluminous hooped skirts, abbreviated versions of nineteenth-century crinolines. This 'Mini-Crini' was to become one of Westwood's most famous pieces, along with the Rocking Horse shoes – a take on Japanese flat shoes with large wooden platforms – which also made their first appearance here.

Westwood sent models down the runway wearing clothes both beautiful and challenging. 'They were a total departure from anything else on the runway,' said Suzy Menkes. 'Vivienne challenged us to think about fashion's role in a world on the brink.'

These collections, as ever with Westwood, weren't just about the clothes. They were a reflection of the anxieties of the day — the Cold War, the fear of nuclear destruction, the class divides in Margaret Thatcher's Britain. There was a growing sense of existentialism, of unease. 'We were living in a world that felt like it was on the verge of collapse,' said Pamela Rooke, a supermodel who walked in both 'Hypnos' and 'Mini-Crini'. 'Vivienne captured that feeling perfectly.'

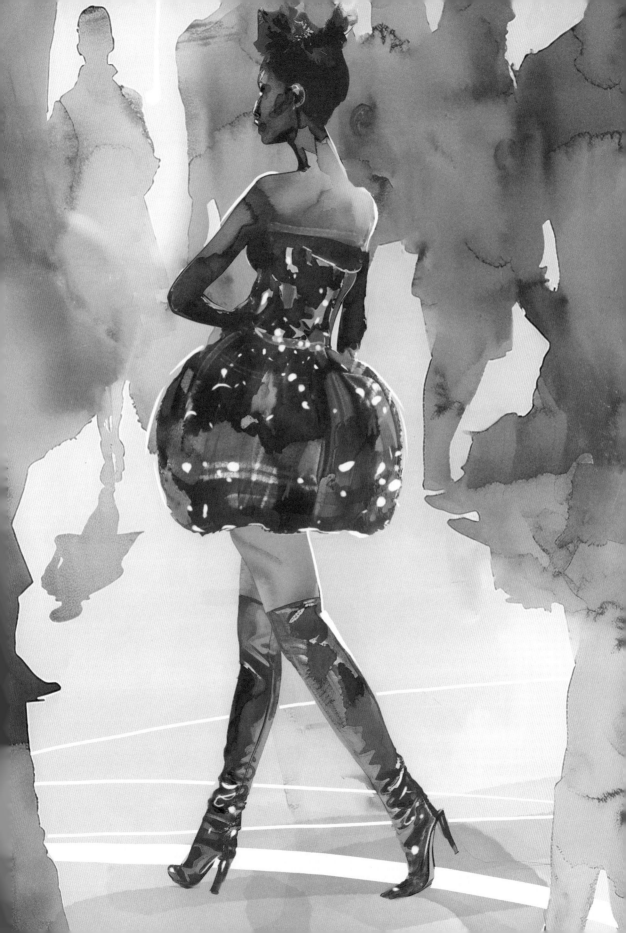

Chapter 6

The NEW
(ROMANTI()
ERA

Westwood's transition from punk to New Romantic wasn't abrupt. Her interest in what would become one of her greatest sartorial odysseys began to show in her designs all the way back to the mid-seventies. She had leaned on, got tired of, then re-leaned on punk and the aesthetics of rebellion as something that had to be sharp and angry. But, even when these were the colours in her paint box, at times a little light crept in.

'THE LAST PEOPLE WITH ANY IDEAS ARE YOUNG PEOPLE.'

Westwood began experimenting with historical ideas in her early collections. One could argue that her redefinition of tartan and the simple American T-shirt was a means of taking from the more recent past and reimagining an immediate future. But, as the era of 'Pirate' came around, she looked further and further back, to other outsiders, for influence – such as pirates and renaissance painters. According to Westwood, at this time she was 'plundering ideas and colours from other places and periods' – all of which would become hallmarks of the New Romantic movement.

As with anything spearheaded by Westwood, New Romantic wasn't just about the clothes. It was a cultural movement born of embracing androgyny, blurring the lines between the masculine and the feminine, and resisting the culture of normality. It meant flowing, ruffle-covered blouses on men, while women wore top hats and tricornes. Make-up was a statement too: pale skin, with pops of bright colours on eyes, noses or cheeks.

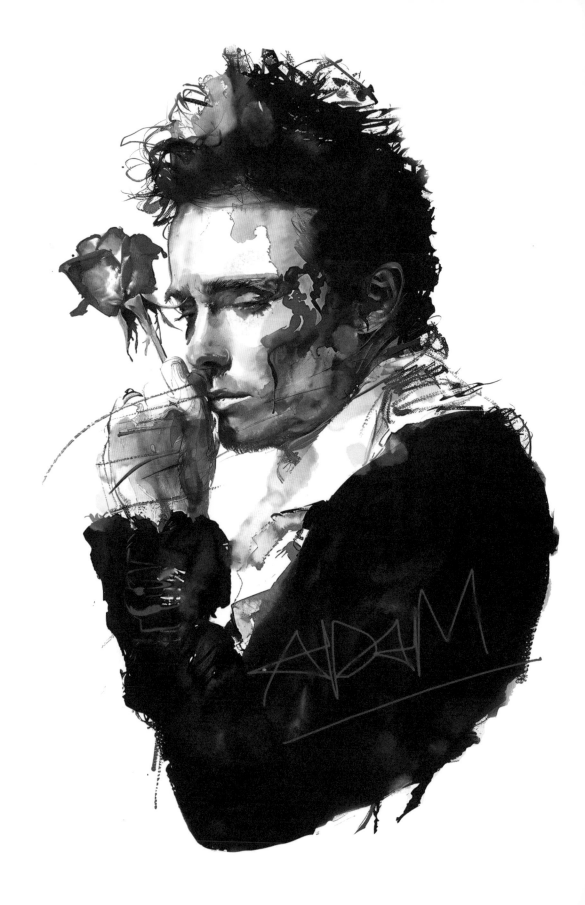

Voluminous shirts and wide-legged trousers were the unofficial uniform – ideas and silhouettes that had started to crop up in Westwood's 1981 'Pirate', and then appeared full throttle in 'Buffalo Girls (Nostalgia of Mud)' in 1982. As McLaren put it, they wanted 'to show in clothes and music that, in the post-industrial age, the roots of our culture lie in primitive societies'. And so Westwood fused this with her deep knowledge of historical garb, as well as an interest in South and North American traditional cultural dress. As Yvonne Gold wrote in *AnOther*: 'It wasn't primitive. It was pivotal and political. It broke all the rules.'

The aesthetic attracted a massive array of artists. The most notable, and perhaps the earliest adopter of the New Romantic style, was Adam Ant from punk/new wave band Adam and the Ants. Westwood designed their signature stage look: pirate shirts, tricorne hats and, of course, bondage trousers. 'Vivienne understood what we were trying to do,' the singer said. 'She wasn't just giving us clothes; she was creating an identity for the band.' David Bowie, Spandau Ballet, and Duran Duran all donned this flamboyant attire, too.

The New Romantic silhouette was loose and floaty. Voluminous shirts had billowing sleeves, while trousers tapered. Waists were cinched and skirts were layer upon layer. Fabrics were luxurious and theatrical: think satin, velvet, lace, all appearing in the same outfit. Accessories were key – namely hats, which were the finishing touch. They were a must-have: from tricornes to top hats, from berets to floppy fedoras. Add chunky rings, necklaces and earrings, and you were on the way. Stephen Jones, the legendary milliner who worked with Westwood over the years, said: 'New Romantic was about taking history and twisting it. It wasn't a costume party; it was a way of expressing yourself through fashion.'

The New Romantic scene's epicentre was in nightlife, specifically at two underground clubs in London: Billy's in Soho and Blitz in Covent Garden. Billy's, with nights dedicated to David Bowie and Roxy Music, laid the groundwork, while Blitz, a former wine bar, quickly achieved legendary status. Steve Strange, the doorman, along with DJ Rusty Egan, made Tuesday nights at Blitz a 'Club for Heroes', where flamboyant fashion came to dance. This scene birthed the 'Blitz Kids' – icons of the New Romantic style.

The New Romantic influence far transcended fashion. It changed music, art and film, inspiring creators and artists with its distinct style, now so associated with the eighties. By the latter part of the decade, the movement had faded, but its impact on fashion and culture remains undeniable. Alexander McQueen, Galliano at Dior, even Gucci under Alessandro Michele, all take New Romantic as their starting point. It was – like punk – a cultural phenomenon. It challenged notions of what men and women should wear, and prioritised self-expression above conformity.

At the end, in 1989, Westwood said: 'The Romantics weren't just about floaty dresses and Byron. They were rebels, too. They challenged the status quo with their art and their lives. That's the spirit I wanted to capture.'

'THE ROMANTICS WEREN'T
JUST ABOUT FLOATY
DRESSES AND BYRON.
THEY WERE REBELS, TOO.'

Chapter 7

ICONIC COLLECTIONS

The 1990s

Westwood is at the top of her game by the start of the nineties. In the 1989 John Fairchild book *Chic Savages*, she is included in a list of the world's top six designers alongside Armani, Saint Laurent, Lagerfeld, Ungaro and Lacroix. Having left art school so abruptly all those years previously, Vivienne is appointed Professor of Fashion at the Vienna Academy of Applied Arts, and in 1990 and 1991 is named Fashion Designer of the Year by the British Fashion Council.

'IN HISTORY, PEOPLE DRESSED MUCH BETTER THAN WE DO TODAY.'

Vivienne Westwood had conquered fashion. So much so that in 1992, to some criticism, it must be said, Westwood visited Buckingham Palace to receive an OBE from the Queen. Now she had recognition from the industry *and* the establishment. She also found a new creative partner in Andreas Kronthaler, whom she met while teaching in Vienna in 1988 and married in 1993. This changed the trajectory of the Westwood brand once again – with influences radically shifting from punks to pagans to posh girls. She was obsessed with critiquing the upper classes from every angle, even by referencing and subverting their aesthetics.

By the end of the decade, Westwood had opened countless new boutiques and launched a fragrance, the famous 'Boudoir'. Her name – and her clothes – had become truly international. It didn't seem as if any more growth was possible, yet still the provocateur's name continued to rise.

PORTRAIT

AUTUMN/WINTER 1990–1991

Finally, shoulder pads were on their way out, as was their number one fan – Margaret Thatcher. Neon brights pulsed through Britain's growing club culture and there was an air of growing optimism in the country. It was against this changing backdrop that Westwood unveiled yet another turning point – her groundbreaking 'Portrait' collection. Still the queen of punk and the New Romantics, Westwood was now firmly accepted as a high-fashion provocateur, and people looked to her to make a statement. But 'Portrait' wasn't a show about shock: it was a true masterclass in reclaiming and rewriting past narratives, this time about femininity.

Visiting the Wallace Collection in London – a museum bursting with Rococo inspiration – Westwood was awestruck. The incredibly opulent portraits with their divine (and restrictive) corsetry gave her an idea. She didn't want to invoke that past, but instead use it to propel new conversations about the female form. And so the centrepiece of this new collection was the now truly iconic Portrait Corset. Made from synthetic fabric, this wasn't the whalebone cage lived in by the women in those portraits. This was a modern marvel: embracing curves rather than constricting them. Of course, Westwood had perfected the cut. Emblazoned on the front was a reproduction of François Boucher's breathtaking painting *Daphnis and Chloe*.

People went wild for it – this historical artwork on show, reimagined on a garment that was usually hidden beneath layers of clothing.

The rest of the show mirrored this interplay between past and future. Bodices were altered and deconstructed, while skirts had added panniers – it was all rather 'Marie Antoinette in 1990'. Hair was piled up elaborately, with feathers and tiny framed portraits nested within. The press were now fans of Westwood – she had essentially defined the last two decades in London fashion. *The Guardian* wrote: 'Vivienne Westwood's 'Portrait' collection is not just about clothes, it's about reclaiming the female form, about taking ownership of our history and sexuality.' *Vogue* hailed her as a genius: 'Westwood doesn't just reference the past, she dismantles it and rebuilds it in her own image. The result is both powerful and utterly beguiling.'

'Portrait' challenged the notion of the corset as a symbol tied only to female oppression. Could it be one of celebration, a certain kind of liberation, asked Westwood, to great applause. In her hands – like so many of the traditional garments that passed through them – the corset became a totem of empowerment and reclamation. The body was now a canvas for self-expression.

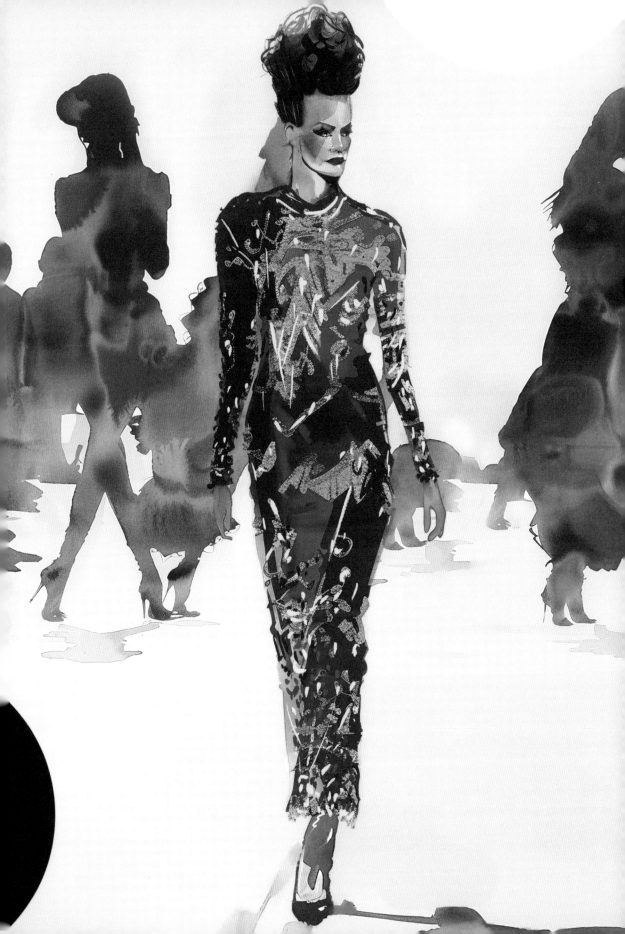

ANGLOMANIA

AUTUMN/WINTER 1993–1994

Westwood had spent much of her time looking elsewhere for inspiration – North America, the Andes, French fashion history and painting – it seemed only fitting that eventually, nearly 20 years after she had started out, she took a look once more at what was happening in Britain. It was 1993 and Britpop was paving the way to Cool Britannia. Finally, it seemed cool to be British. At the Atelier Versace, an unlikely venue for such a subversive genius, Westwood gathered an intimate crowd to present her reclamation of British fashion heritage.

'Anglomania' was a love letter to all things British. Tartans became miniskirts and sharp-tailored jackets, denoting her ongoing fascination with Scottish clans. Corsets, now a crucial part of her design vernacular, reimagined the Elizabethan era. Kilts became flowing skirts, and vertiginous heeled platform boots lifted models sky-high. All were topped by with hats adorned with giant feathers – a nod to British aristocracy. Every era of British fashion history seemed to blend seamlessly into one collection. This was a comment on British identity: one of eclecticism, created by global influence and, indeed, by a history of colonialism. Westwood's critics, accustomed to her two fingers up at everything, were disarmed by her out-and-out celebration. But it was the time for it: Blur and Oasis topped the charts, while Kate Moss and Naomi Campbell were fashion royalty.

Speaking of Campbell, the finale of 'Anglomania' might be one of the most famous runway moments of all time. Out walked Naomi, the reigning supermodel, dressed in a tartan suit draped in a ruffled boa. All eyes were on her, in her precariously high, blue mock crocodile 'super elevated' platform heels with ghillie lacing. At the end of the runway, having made her way skilfully though the atelier, she took a fabulous tumble, with a signature Naomi Campbell elegant flourish. The audience gasped; time stood still for a moment. Naomi – ever the pro – laughed and rose to her feet, as the ruffles cascaded around her. It merely spurred her on to finish the runway with an even bigger smile than before – a perfectly British, and a perfectly Westwood, moment.

'Anglomania' was Westwood's masterwork after years of research: a study of rejection and acceptance, leaving and returning, to a culture you both detest and have pride in. Once again, Westwood opened the door for continuing conversations in fashion – this time about national identity and the role of clothes in honouring and keeping alive, while simultaneously tearing down, tradition. She was unstoppable, delivering show upon show of ingenious provocations for both fashion and the world. By now, she had become a truly peerless designer.

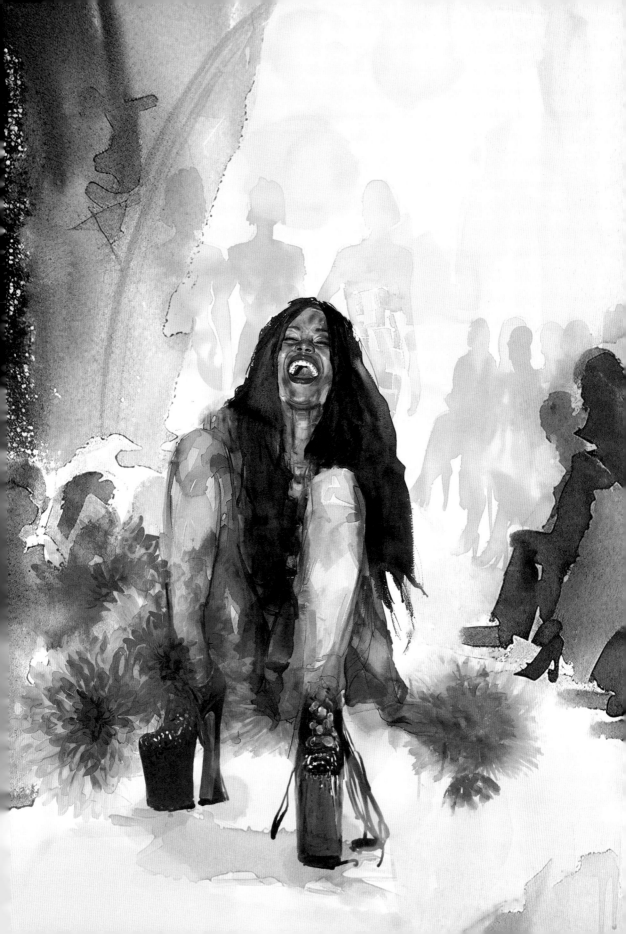

CAFÉ SOCIETY

SPRING/SUMMER 1994

Grunge ruled the airwaves, and the world felt as if it was in flux after the fall of the Berlin Wall. Amidst the rise of flannel and Doc Martens, Westwood was turning increasingly towards opulence (with a critical eye, of course).

In Paris, at the decadent Grand Hotel, this show was a spectacle. Supermodels such as Kate Moss, Naomi Campbell and Christy Turlington took their turns down the runway – their youthful demeanour contrasting the faded decadence of their surroundings. Moss, in a now truly iconic moment in fashion history, walked the runway naked from the waist up, eating a Magnum ice cream. It was an audacious act, which jabbed at the bourgeoise. This was Wetswood's subversive yet glamorous take on high society.

She had started with the work of nineteenth-century French fashion designer Charles Frederick Worth, who was the founder of haute couture. He was known for his exaggerated silhouettes: cinched waists, voluminous bustles, flowing ruffles – all created in luxurious silk and taffeta.

Westwood loved it, and found great inspiration in it, while simultaneously shooting the collection through with her punk roots. Tartans and other garments were ripped; safety pins held the pieces together.

The collection coincided with the rise of the supermodel era, a truly legendary moment in nineties fashion. And 'Café Society' only confirmed the power these young women carried on the runway. They were becoming cultural icons who transcended fashion; they were becoming the new 'high society'. Moss, with her modish, unconventional beauty, became the face of the new cool.

'Westwood's 'Café Society': Scandal at the Grand Hotel,' read the headline in *The Independent*. Some found the whole thing vulgar, others called it a masterpiece. Westwood was now casually playing in the realms of high fashion: her garments were incredible, and her references were rich and well researched. She was unafraid to take on the nineteenth-century father of couture and re-imagine his look for today.

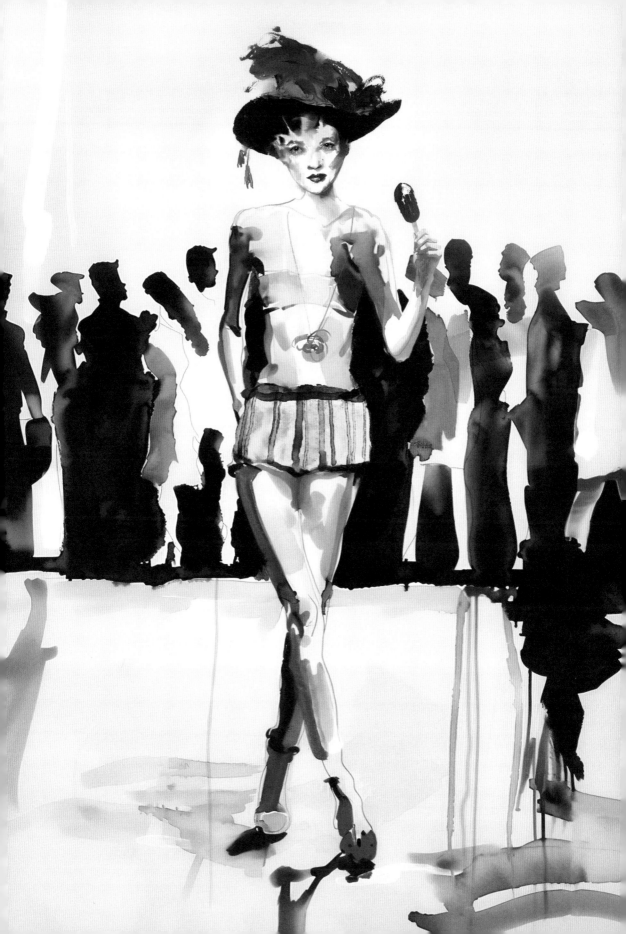

ON LIBERTY

Like 'an ant on stilts' is how Westwood described the silhouette for her collection 'On Liberty'. It was the time of both Britpop and Girl Power – a time when it seemed great to be British, something she had celebrated in her previous collections. But now Westwood looked back to a time when it hadn't been as great, and chose to deconstruct and reconstruct the elegance of Victorian tailoring … with her trademark punk twists. The collection was about asserting individual freedom, and taking that history and imagining it differently, inspired by English philosopher John Stuart Mill.

This collection was famous for its 'bum pads', which Westwood used to accentuate, even over-exaggerate, the female form. A long teal frock coat, in velvet, which squeezed right in at the waist, was teamed with a clashy cardi and a mini-kilt. It was tailored anarchy: all the edges frayed, the garments tattered intentionally. This was Westwood's controlled chaos – a critique of the sometimes constricting nature of femininity, while simultaneously celebrating its beautiful and interesting proportions. Textures clashed too: beautiful velvet met its match with rough raw silk; stockings were crocheted; beautiful raffia flowers emerged from heels. Because even fashion's most avid critic loved whimsy, too.

The optimism of the era didn't quite gel with Westwood's tendency toward darkness. Some critics hailed her as a genius, exalting the collection's innovation and outrageousness. But others seemed to want something more in keeping with the time. *Vogue* said: 'Westwood's women are not for the faint of heart.' Were people growing tired of all the questions Westwood still wanted to ask?

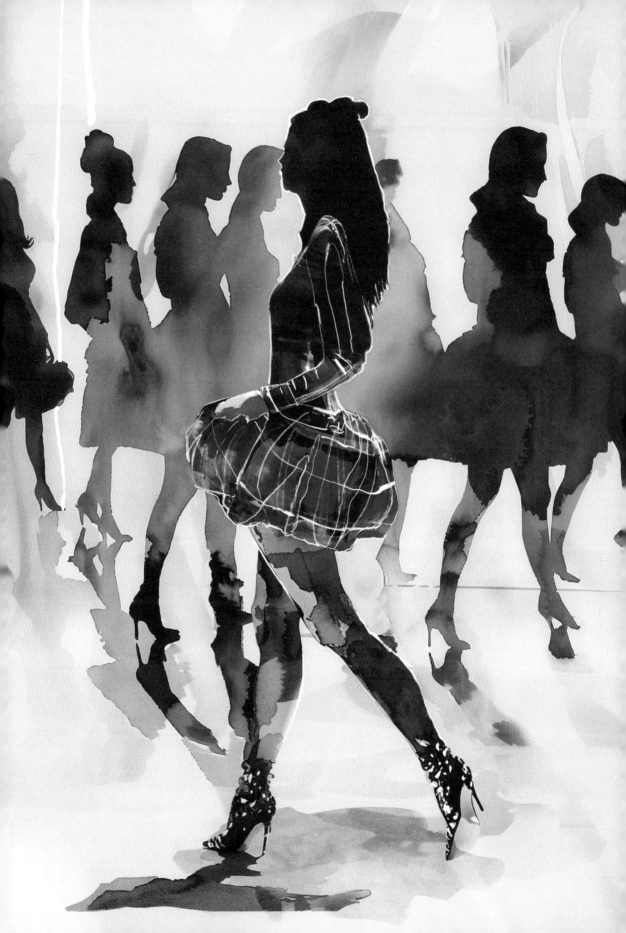

'MY CLOTHES HAVE A STORY.
THEY HAVE AN IDENTITY.
THEY HAVE A CHARACTER
AND A PURPOSE.
THAT'S WHY THEY BECOME
CLASSICS. BECAUSE THEY
KEEP ON TELLING A STORY.
THEY ARE STILL TELLING IT.'

EROTIC ZONES

SPRING/SUMMER 1995

Riffing on a similar theme to 'On Liberty', Westwood continued with an exploration of the erotic zones of the female silhoutte. Necklines plunged, corsets cinched, and dresses were cut right down to the lower back. Proportions were ever so slightly distorted to bring a playful eye to unusual – and arguably very taboo – parts of the body. Skirts were cut on the diagonal, rising high at the back and revealing the thighs, while giant hoods shrouded the heads of many of the models.

This was a game of conceal and reveal – with some garments literally deconstructing on the runway, unwrapping from the neck, to reveal the chest. One of Westwood's most famed pieces arrived in this collection, known as the 'bum-cage' – or *cul* cage – it was a cage bustle that went around the waist and accentuated the curve of the buttocks. These were fabricated by the father of her partner, Andreas Kronthaler.

'The girls were never more covered [than] the first three that came out, and yet all the photographers were just groaning and moaning immediately. And I thought why are they doing that?' Westwood told the press after the show. 'Because the girls look so sexy because of this special shape. It does depend on the very high heel, and this form around the hips, the bum, and that makes the waist really, really narrow.'

In today's world of normalised extreme body modification, this silhouette doesn't seem so radical, but back then Westwood was continuing to push the boundaries of the body, and the mind.

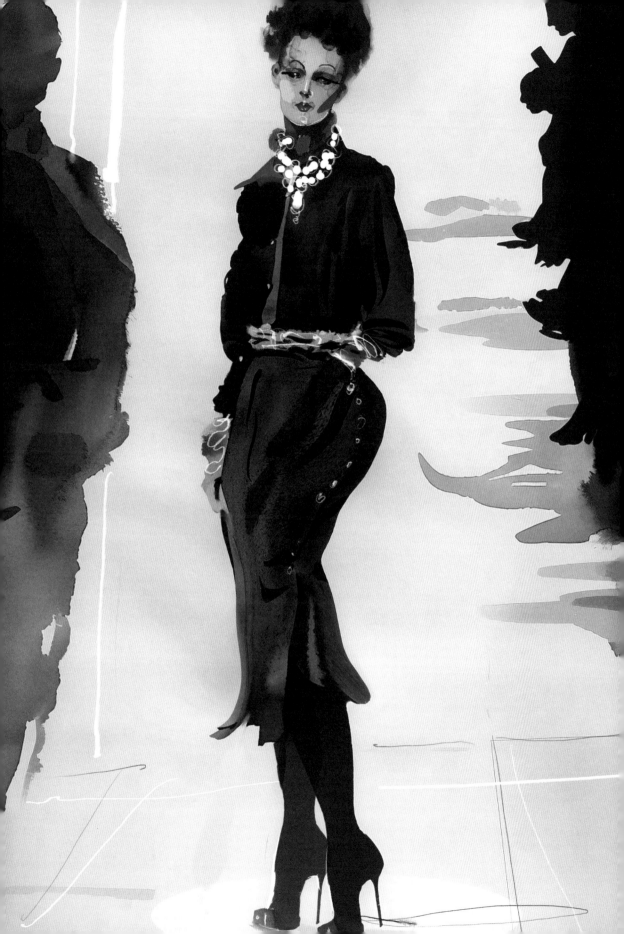

VIVE LA COCOTTE

AUTUMN/WINTER 1995–1996

It was 1995 and the Spice Girls would soon be releasing 'Wannabe. The UK was on a political upturn and crackles of Tony Blair's New Labour were inspiring optimism. Music was ruled by pop and grunge, and fashion by little black dresses and sportswear. But Westwood, never one to play in the mainstream, was looking elsewhere: at the royals. And her 1995 collection 'Vive La Cocotte' exploded onto the Paris runway.

It wasn't just a collection. It was a declaration – once again that she was here to defy the trends of the time. They weren't of interest to her. Now she had turned her eye to the seventeenth and eighteenth centuries, with a love letter to the opulence of the typical court dress of the time. Corseted waists made her models look like wasps, while full skirts swept the ground, or sometimes the thigh. It was fashion for grand ballrooms with even grander fabrics: rich brocades, shimmering velvets. Satins gleamed next to beautiful lace, and jewel tones of sapphire and emerald sat unexpectedly next to black and white. It was bold and dramatic. Much of it rich, yet much

of it stark. Never one to tread timidly, Vivienne included pops of fire, red and shocking pink.

Westwood's timing couldn't have been more typical. The world of fashion was fast becoming obsessed with casual wear, and so was caught off guard. Alexander Fury, legendary fashion critic, said that this show left people 'flummoxed' – yet so many were enthralled. If the world wanted feminine, Westwood gave people androgynous. Now the world wanted androgyny – baggy clothes and formless tracksuits – and Westwood gave them silhouettes. The New York Times wrote off 'Vive La Cocotte' off as 'a costume party', but now it's regarded as one of her landmark collections.

Only Westwood could breathe new life into such dusty history. She allowed the world access to a whole period of sartorial exploration that was otherwise being overlooked. This was Westwood's celebration of craftsmanship, of detail, of anything but casualwear – a term that feels distinctly un-Westwood.

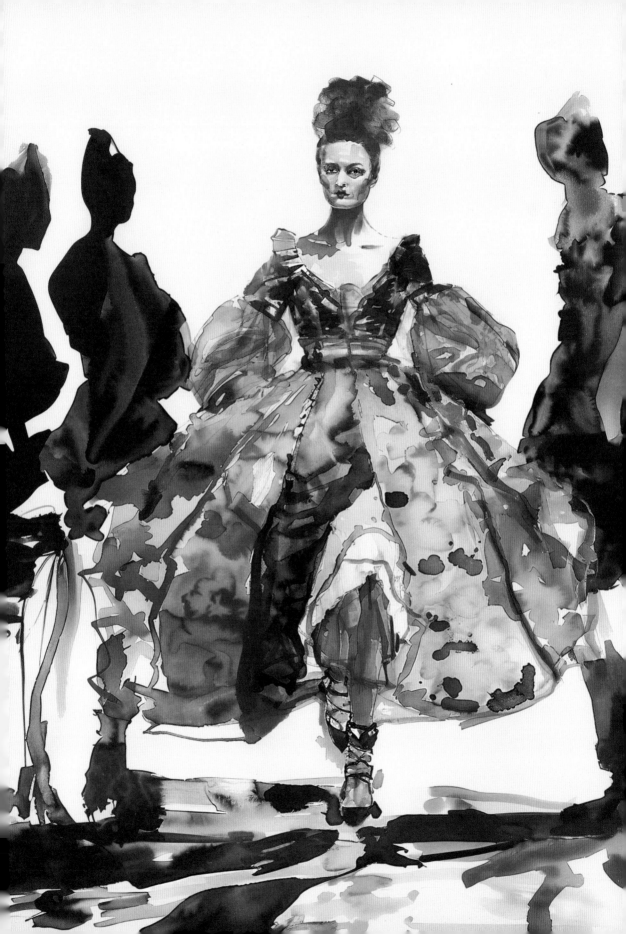

Chapter 8
DIFFUSION

By the late nineties, very few stones were left unturned with regard to Westwood's creative curiosities and the ways they intersected with her designs. She had been heralded as one of the world's most important fashion designers, yet, even as her stronghold became more securely fixed, her frustrations with fashion's limitations grew. Collections had always been drawn down gender lines – an idea that was particularly entrenched at the time – and the growing cost of putting on a show meant that designs had a responsibility to sell, sell, sell. These pressures continue in fashion today, but Westwood craved more freedom – more spaces in which she could follow her nose, push herself, ask questions.

Slowly Westwood's label began to diffuse into multiple different lines. She founded Man, where she could create a whole world for people who were interested in men's clothing. Then Red Label – a more accessible, affordable line, which set her the challenge of putting Westwood ideas into clothes that could be worn every day. Gold Label became about ultimate creative freedom. Anglomania was about exploring her own archive. And Bridal? Well, that was about creating the Westwood bride (a bride who lives on keenly today).

Ideas spilled over, of course, between the lines, because she understood that creativity wasn't confined to a label sewn into clothes. But these new parameters she set for herself deepened and expanded the Westwood world.

'I'M NOT TRYING TO DO SOMETHING DIFFERENT, I'M TRYING TO DO THE SAME THING IN A DIFFERENT WAY.'

MAN

At the Grand Palais in Paris, everyone who was anyone hustled to get a seat. This was it: Westwood's first ever menswear collection, a collection that not only heralded a change in the tide for Westwood, but also a change in the tide for fashion. There was a men's market beyond Savile Row, and of course Westwood was quick to blaze the trail. She called the line Man, which is what her menswear stores all over the world are still called today. Man was saying: out with stuffy, suited and muted, and in with a rebellious spirit, in with a redefinition of masculinity.

This wasn't Westwood's first foray into menswear – arguably her most famous early designs had been those worn by the punk bands of the seventies. But this collection was quite different to what she'd created way back then. In the years since, she had become a rebel darling of fashion, and had honed her craft and her technique. By now, she was known both for her anarchic spirit and her impeccable technical skill.

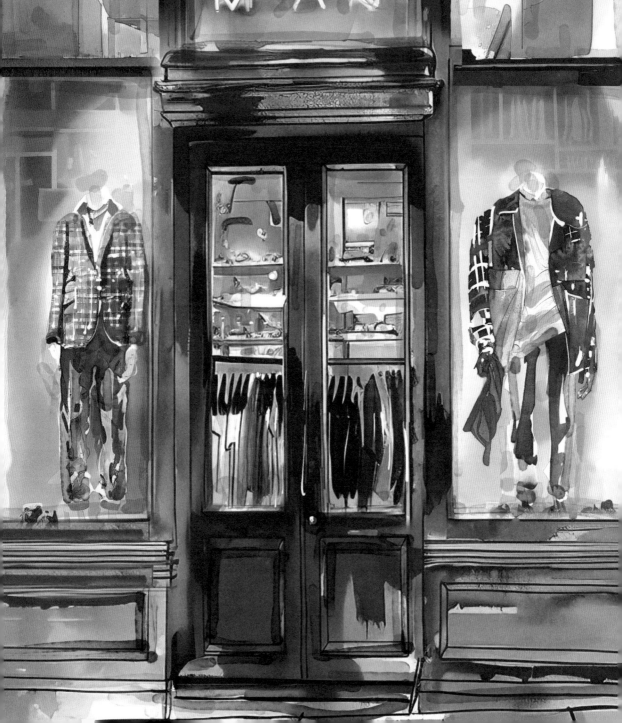

So what did menswear mean, then, in the late nineties? To Westwood it meant subversion – taking what men traditionally wore and warping it all. She started with leather: butter-soft biker jackets with built-in wear-and-tear were cropped and worn alongside tartan trousers. Wool suits were tailored to perfection, then cut asymmetrically to reveal flashes of tartan lining. Yes, indeed, she could do Savile Row, if she wanted. Harris tweed, one of Westwood's most favoured fabrics, was reimagined in geometric patterns and the cuts were slim and somewhat androgynous, harking back to her days at SEX on the King's Road.

Music from the Sex Pistols and The Clash soundtracked that first show: a deliberate nod to Westwood's past, where her journey with menswear had begun. At the end of the show, she famously exclaimed: 'I think men are much more interesting in kilts.'

'IT IS NOT POSSIBLE FOR A MAN TO BE ELEGANT WITHOUT A TOUCH OF FEMININITY.'

One of the most renowned pieces from the show is perhaps the Martyr to Love jacket – a beaded trompe l'oeil corset jacket, depicting a muscular male torso made from beads and sequins. The jacket was co-constructed with legendary corsetier Mr. Pearl and worn by Greg Hansen on the runway. It was genius, and unlike any other menswear previously seen.

And so began her lifelong conversation with men's clothing. Vivienne featured everything: suiting to kilting; bags to shoes; clothes to rave in; clothes to sleep in. Through it all, her menswear vision remained clear: challenging silhouettes, impeccable tailoring, fearless ideas and an ongoing conversation with her womenswear.

'YOU'VE GOT TO INVEST IN THE WORLD, YOU'VE GOT TO READ, YOU'VE GOT TO GO TO ART GALLERIES, YOU'VE GOT TO FIND OUT THE NAMES OF PLANTS. YOU'VE GOT TO START TO LOVE THE WORLD AND KNOW ABOUT THE WHOLE GENIUS OF THE HUMAN RACE. WE'RE AMAZING PEOPLE.'

ANGLOMANIA

Westwood launched Anglomania in 1998 as a line that provided a space to return to old designs – to reimagine and explore them. By now, the fans of Westwood were many, yet pieces from her early years were incredibly rare. Customers – both wearers and collectors – were crying out for access to those early, brilliant ideas.

Anglomania was all about youth, and about reflecting on those ideas Westwood had had when she was young. Across Anglomania's collections, she explored styles from SEX, 'Pirate', 'Mini-Crini', bondage – revisiting her early designs with even more confidence.

'INSTEAD OF BUYING SIX THINGS, BUY ONE THING THAT YOU REALLY LIKE. DON'T KEEP BUYING JUST FOR THE SAKE OF IT.'

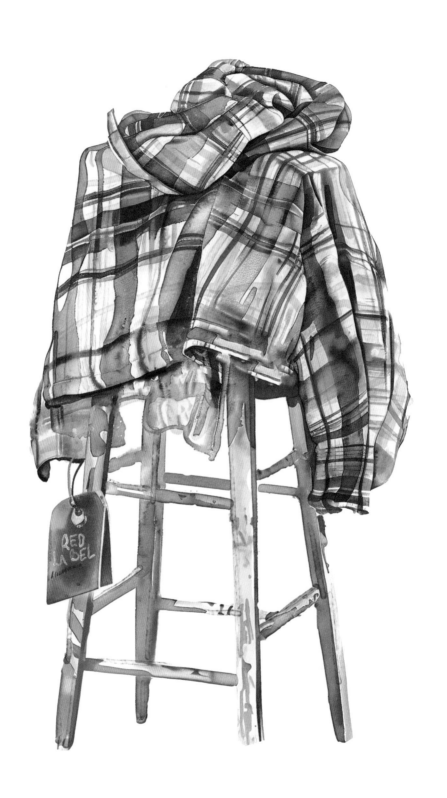

RED LABEL

Westwood had tackled the monarchy and the patriarchy; she was a doyenne of music, fashion, art, even politics. But one thing she hadn't quite cracked was the inaccessibility of her designs. Not only were the clothes she created unwearable to many, but they were priced at a point that proved too high for the majority. So she did what so few in fashion dared to do: she decided to democratise, to make her clothes accessible to so many more. This is how she came up with Red Label, her diffusion line, which ran until 2016.

Red Label was legendary: it offered Westwood's creative genius in everyday, wearable clothes, in fabrics that didn't break the bank. It brought her signature subversive style to more people and posed a creative challenge for Westwood, too: could she design something that the masses would wear? She'd been obsessed by reinterpreting the classics – whether it was the T-shirts of her early career, or tartans, or her traditional regal wear – but could she make jackets, skirts and dresses that felt like Westwood, yet could be hung in the wardrobes of stylish young women everywhere?

Imagine a young, peppy Sloane Ranger venturing into the world: what does she wear? That was Westwood's provocation for herself, and what she came up with was a Red Label wardrobe full of playful combinations of textures and fabrics. Think crisp cotton poplin shirts, but with frayed hems. Think tailored wool trousers, but with a relaxed fit. She was rebelling against tailoring, rebelling against herself.

'OUR CLOTHES [FROM RED LABEL] TELL STORIES AND MAKE PEOPLE FEEL LIKE CHARACTERS. I THINK THAT GIVES PEOPLE AN EXTENSION TO THEIR PERSONALITIES, AND THEY START TO DISCOVER THINGS ABOUT THEMSELVES.'

Westwood also incorporated classics into her Red Label collections over the years. Camel coats, brocade dresses, British tweeds and tartans were a feature throughout the whole life of Red Label. Put one of her miniskirts with a chunky knit and it just felt so youthful. Her palette for these collections was more muted, more blendable, more tameable. Think deep earthy tones of bottle green, burgundy, mustard yellow and the odd shock of royal blue. This was a confidence, a surety. She made tees, cardigans, shirts. And, despite their democratic intentions, they always remained thoroughly Westwood.

Over the years, these Red Label shows took place all over the fashion capitals: in the financial district in New York, in a disused public toilet in Soho. Where would her Red Label girl travel? Well ... just about anywhere. And she looked great doing it!

By this point in her career Westwood had dealt so much in luxury that her interest had started to turn elsewhere. Red Label was different: it challenged the very notion of how a designer fashion line should look like. The name itself – 'Red Label' – was Westwood's subtle dig at luxury. But, of course, neither the quality nor the skill in design changed or faltered. This wasn't a watered-down version of Westwood's mainline collection in order to hawk another thousand units. This was its own distinct entity: where her craft could take on classic garments, and where her love of British heritage and punk subversion could mix and marry in new, creative and wearable ways. Westwood saw it as a gateway to exploration.

GOLD LABEL

The idea of a Gold Label had been circling in Westwood's head for a while. Since Naomi took her tumble, and the world's eyes turned to Westwood's craftsmanship in Paris, the house had commissioned its own MacAndreas tartan, named for her now-husband, Andreas Kronthaler. Their work as a fashion house was increasingly unique, increasingly luxurious. And so, around the time she had the idea for Red Label, she decided to split her collections in two: Red and Gold. Democracy and couture.

Gold Label took a dramatic turn. This was not about wearability, but was instead a forum for Westwood to explore her creativity unbridled: without care or question as to whether something might sell (it did) or whether someone could wear it to a job interview. With Red Label and Man, she'd conceded – and rightly – that women and men alike needed clothes that were stylish, elevated, but ultimately could factor into their daily wardrobes. In Gold Label she wanted to create a forum for beauty, to push her designs.

She used the most luxurious fabrics: plush pile velvet draped across the body, duchesse satin caressed the skin, brocades brought sheer opulence. Of course, she eventually got bored with sheer limitless luxury and, across the years of Gold Label, Westwood played with everything, bringing cotton, hessian and even wicker into the high-design fold. But, no matter what materials she used, her work was always opulent, always explorative, and always asking questions of style and design.

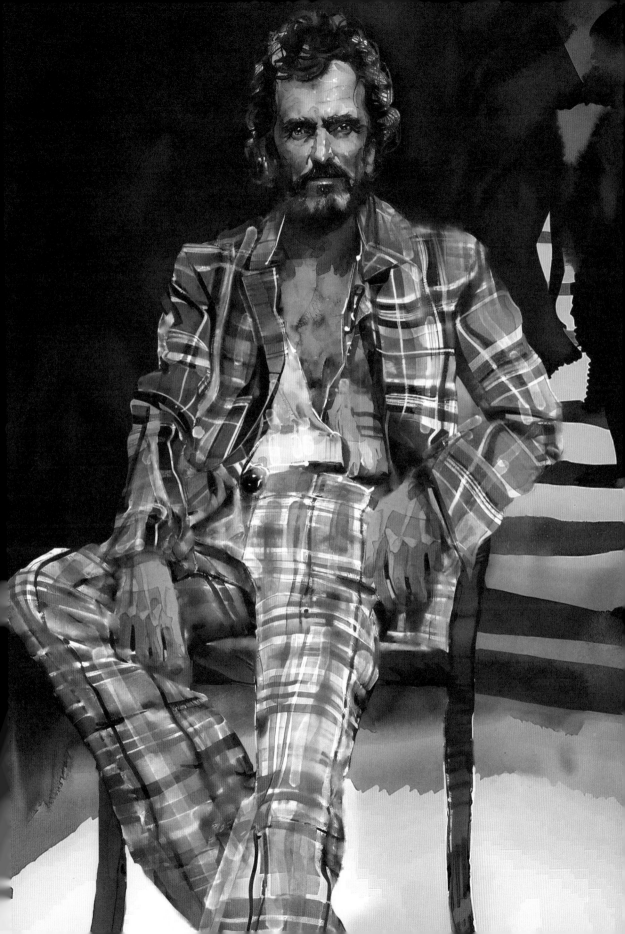

In her early collections, jewel tones ruled – sapphires, rubies, emeralds, all in a shimmering array. The cuts were a masterclass in tailoring: jackets had perfectly nipped waists and strong shoulders; waspy corsets abounded. She would drape and sew, and create brand new silhouette-altering patterns (which would also filter through into her Red Label work).

All her collections were in conversation with each other. With Gold Label, Westwood had the opportunity to push her designs to a limitless place of creativity. In Red Label, she gave herself parameters – parameters which, of course, drove her design work further.

What remained across all her collections, no matter the label, was Westwood's innately subversive nature. Even the classicism she invoked with Gold Label would be subverted: an angular neckline slashed across an otherwise perfect velvet dress; a seemingly perfect and prim skirt revealing a daringly high slit all the way up the back.

Westwood had given herself a hard task – couture! Notoriously impossible, unsellable, and often uninteresting. But, once again, her flair and true artistry cut through any outdated structures. Gold Label was a commercial and critical success, adored by collectors, fans and critics the world over. As she famously said: 'You have a more interesting life if you wear impressive clothes.' And that's what Gold Label was all about.

'I DO THINK IF YOU AIM FOR QUALITY, IT'S NOT SO MUCH ABOUT CONSUMERISM.'

BRIDAL

In 1992, Westwood introduced wedding gowns into her collections. It made sense
– corsets; voluminous, draped fabrics; historical cuts, to match Westwood's love
of exploring the fashions of the past (and, of course, the historical nature of the
institution). Naturally, these were an immediate hit.

Perhaps the most famous wearer was the iconic Carrie Bradshaw, in *Sex and The City:
The Movie*, where the storyline had Vivienne personally gifting the ultimate fashion
girl the ultimate dress. Following the film, a knee-length version of the dress was
made available on Net-a-Porter – they sold out within hours of release. The iconic
dress was revived for Carrie's night at the Met Gala in the sequel series, *And Just
Like That*, with additional teal-coloured accessories – a recycling concept that spoke
beautifully to Vivienne's tenet of 'buy less, choose well, make it last'.

Over the years, Westwood made wedding dresses of all kinds – tartan, purple,
sequinned, dramatic and demure – and numerous stars, from Pamela Anderson to
Miley Cyrus, have been married in an iconic Westwood bridal design.

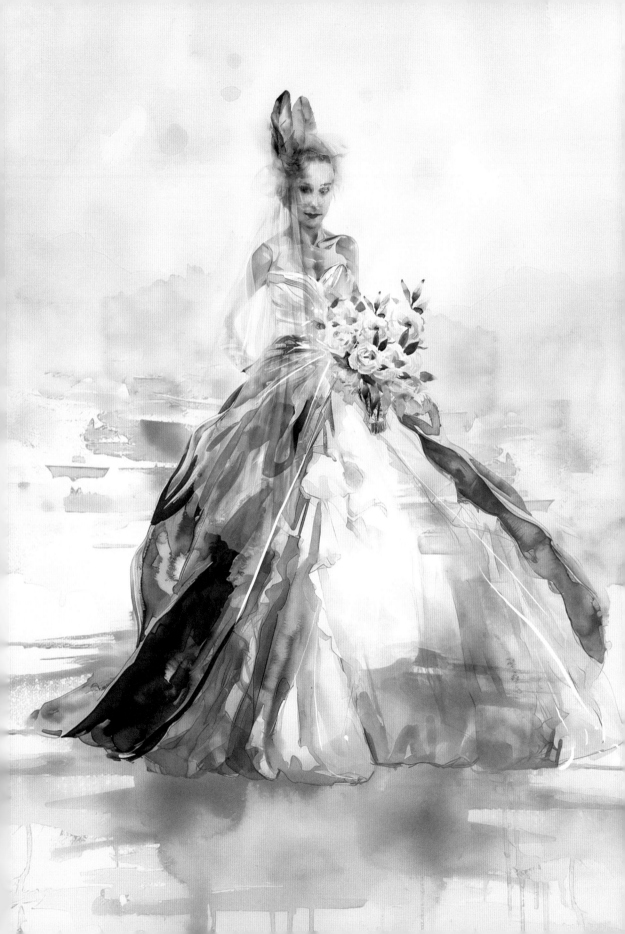

Chapter 1
ART, CLIMATE, MONARCHY

Things were changing once again and in luxury fashion (hard to believe now) there was a fear of the internet. But, as always, Westwood went boldly where few others dared. In 2001 she opened her online store, viviennewestwood.com. Today, when a website can be launched from a phone in a matter of minutes, this might seem a small step, but back then it was a forward-thinking move that mirrored Westwood's seemingly innate ability to adapt. And to march into the future with as much bravery as she delved into the past.

Around the turn of the century the Museum of London launched a retrospective of Westwood, the designer and artist, with an emphasis on the latter. The exhibition was called *Vivienne Westwood: The Collection of Romilly McAlpine* and it truly cemented Westwood's place as a cultural influence across multiple mediums: fashion, music and now art. And so the boom continued – she opened boutiques in Asia, and won global awards for her innovative design.

'We had ten very, very hard years,' Westwood said at the time, of her early life as a fashion designer. Right up until the time of 'Mini-Crini' she had been living hand-to-mouth. Now, with her Red and Gold Labels, and with status as one of design's few, true greats, Westwood was able to explore varying creative pastures – namely a design collaboration with another titan of fashion design, Rei Kawakubo of Commes des Garçons. Their collections were launched exclusively in Milan and Japan, to celebrate the 2003 opening of Westwood's Japanese boutique. She also collaborated with British fine china company Coalport on her first Westwood Home Collection, another innovative move to expand her field of vision when it came to design. She was always reinventing the wheel: showing other houses that you could expand commercially while maintaining creativity and a political viewpoint.

'FASHION IS VERY IMPORTANT. IT IS LIFE-ENHANCING AND, LIKE EVERYTHING THAT GIVES PLEASURE, IT IS WORTH DOING WELL.'

In 2004 the V&A also hosted a Westwood retrospective – the first time the iconic museum had ever done so for a single designer. It was huge. Fans flocked from all over the world, thereby proving not only the thirst for Westwood, but also the dedication that true creativity can engender in people. It showed that fashion really is an art form – one worth considering for its intellectual and creative heft, for its ability to comment on the state of the world, to be political, to be smart – and worthy of display in one of the world's most important art museums. Westwood – the once decried punk of the King's Road – had conquered the world, in so many ways. And she'd retained her imagination and sense of humour while doing it.

By now she had done it all, but she still had so much to say. She became a dedicated advocate for environmental and social causes on a global scale. She had always been outspoken against the system. She had hated Thatcher, the government, the monarchy; she couldn't stand traditional gender roles, and railed against homophobia and racism. In 2012 she launched 'Climate Revolution' – a global platform for her activism, and that of many others, which is still up and running today.

Despite her inclusion in the mainstream, in many ways Vivienne remained an utterly dissident voice, never shying away from her politics, and the power of her clothes in communicating them. Her No Nukes tees became an instantly iconic anti-war uniform. Her work to highlight global injustice throughout the AIDS crisis saw her stand in fearless solidarity with people all over the world. 'Fashion is the most powerful thing on earth,' she would say. 'It's more important than museums and galleries.'

'I'M VERY LUCKY.
THE PUBLIC HAPPENS TO
LIKE ME. MAYBE THEY LIKE
ME BECAUSE I USE EVERY
OPPORTUNITY TO TALK
ABOUT INJUSTICE.'

It was activism to which Westwood now devoted her life: environmental protection became her main work, as well as her fierce defence of WikiLeaks founder Julian Assange. And where else would she stage these rebellions, these activist protests, but on her runways? Theatre and visual art have always been a crucial part of activist practice, so Westwood would stage a climate protest in the streets, everyone dressed in her clothes, or send Naomi Campbell down the runway in a wedding dress covered in blood to protest the use of fur in the fashion industry. Every stone of injustice she could overturn, she would. Entirely jeopardising her chances of reaching super-global, mega-money levels of success and fame, she would never be like other designers, who found cheap production and hiked up their prices. Westwood remained true to herself, despite all that had changed around her, and that was because she had always been a critic. She had always asked questions of herself, of the industry, of the system.

Her influence and her duty transcended fashion. In 2006, she received her Damehood from Prince Charles, which surprised many fans, since she had started her career as a true critic of the monarchy. Upon receiving her OBE in 1992, she famously twirled her skirts for photographers outside Buckingham Palace and 'accidentally' revealed she was wearing no underwear. A truly punk move. But elsewhere it didn't seem as though she was softening politically. As her husband Andreas said, 'she has never stopped questioning, never stopped evolving' and she believed her Damehood to be representative of her incredible journey from working-class girl. Indeed, there has been no journey quite like Vivienne Westwood's.

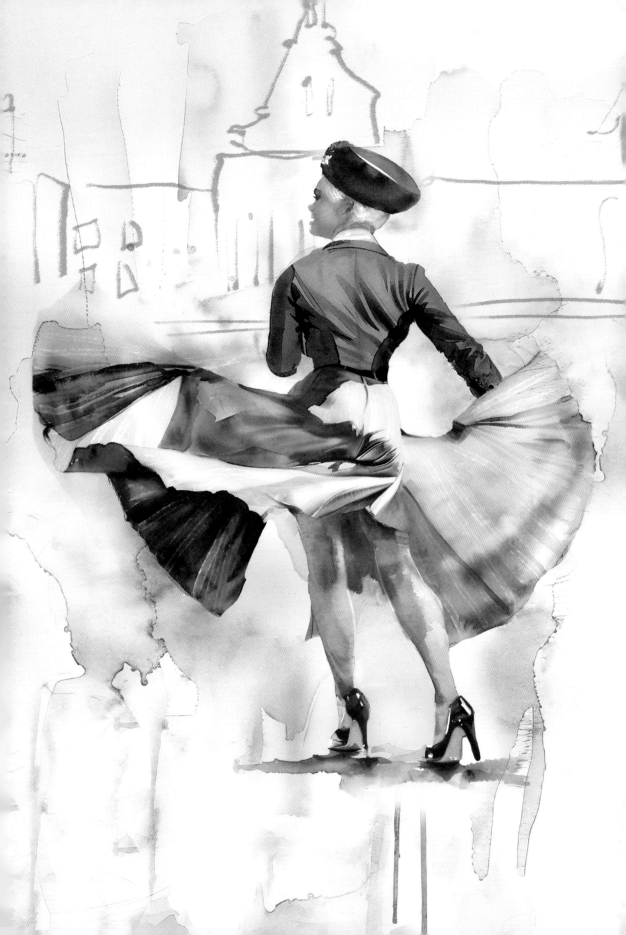

Chapter 10
ICONIC
COLLECTIONS
The 2000s

After the millennium, things started
to take a different turn on the
Westwood runway. Following the
year 2000, culture seemed to change
somewhat. The world's anxieties
about what would really happen when
the millennium hit were met with
a rather anti-climactic reality: that
things, at least for now, would stay
the same.

'WHAT I'M ALWAYS TRYING
TO SAY TO THE CONSUMER IS:
BUY LESS, CHOOSE WELL,
MAKE IT LAST.'

But things would not stay the same for Westwood – the year 2000 saw her collaboration with husband and creative partner Andreas Kronthaler grow and grow, and their runways would become a fever dream of activism and design. Of power dressing and power critique.

Westwood became obsessed with literature and its heroes for the first few years of the new millennium. Her first collection of the decade, entitled 'Love's Labour's Lost', featured Shakespearian-style cloaks and hefty silver jewellery. 'Reading is the biggest passion of my life,' she declared at the time – her designs paying homage to everyone from Artistotle to Huxley. In her Spring/Summer 2001 show, cloth was folded into rectangles to represent open books, while butterflies and insects flittered across the garments.

For her Autumn 2001/02 show, Westwood explored animal prints and textures. 'Wild Beauty' famously presented her granddaughter, Cora Corré, in her runway debut at just three years old. The clothes featured curved seams with everything pieced together to represent animal hides. For Spring the following year, she looked at mythical fairies in 'Nymphs', inspired by the art of Fragonard and Boucher. These nymphs wore long eyelashes crafted from feathers, while traditional rugby sweaters made for a classically British, yet totally clashing, aesthetic.

Post millennium, Westwood's boundless creativity seemed to work with more fluidity. What became clearly paramount was her growing commitment to her politics. In 2001, when the horrors of 9/11 took place and the world changed forever, Westwood and Kronthaler's political drive solidified. The world was in pain, suffering from various overlapping systems of oppression and exploitations of power. Where better to decry these ills than on the runway – this global platform that Westwood and Kronthaler had so successfully created?

ANGLOPHILIA

AUTUMN/WINTER 2002–2003

It was 2002 – the year of Queen Elizabeth II's Golden Jubilee – the perfect opportunity for Westwood to revisit her obsession with Englishness, with the upper classes, with the monarchy. The celebrations created the ideal backdrop for her show, which featured fraying knitwear, historical references and a pulled-apart, crumpled silk Madame de Pompadour dress (modelled on a painting by François Boucher). This collection also featured the red dress that Westwood named as her favourite she'd ever designed — and she'd designed a lot of red dresses!

Cuts were asymmetric, models wore giant fake fur coats and snagged Argyll-knit body stockings. With muted yet rich tones of maroons, browns and golds, tweed and tartan, it was a subdued segue from her famed 'Anglomania' collection, but perfect for the new millenium.

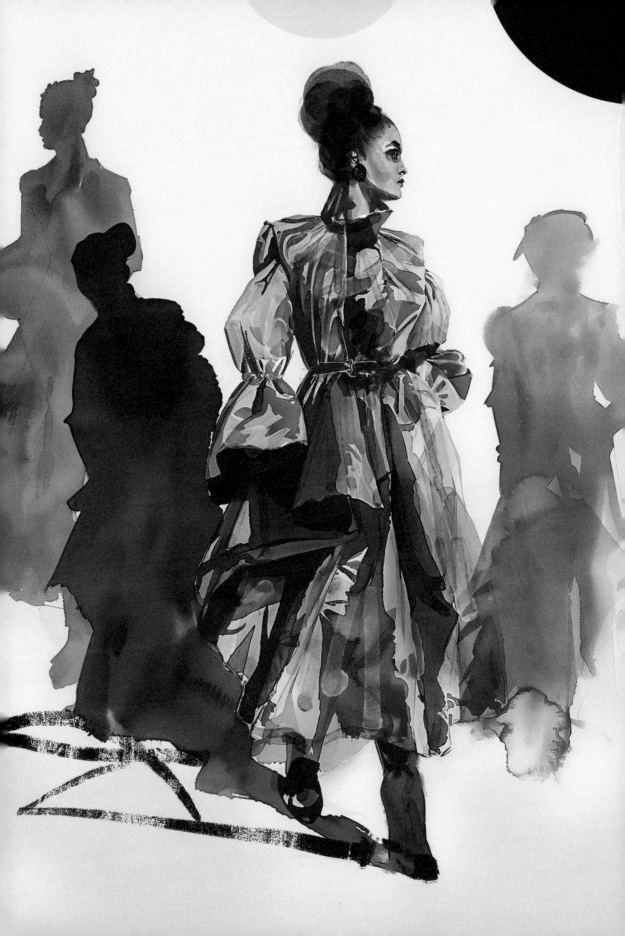

AUTUMN/WINTER 2009–2010

This collection was inspired by the artist Andrea Mantegna. It featured a burnt orange palette and knitwear resembling Renaissance armour – asking what might we wear when the earth's temperature rises by five degrees. And that was the show's title: +5°. Westwood's prediction was that if the environment continued to heat up there would be only one billion people left on earth by 2100. Her idea was that through 'Loyalty 2 Gaia' (the collection's central slogan) we could reconnect with the earth and its needs.

Critics seemed less enamoured with the actual collection. In *Vogue*, Tim Blanks wrote that there were 'stinkers'. But by now Westwood didn't seem overly obsessed with proving her design mettle – she had, some fifty years into her life as a designer, very much already done so. The collection was variable – clothes thrown together in clashing prints and silhouettes – and yet so distinctly Westwood. Her pink tartan, squiggle and tribal prints made a return in this post-apocalyptic world that Westwood absolutely did not want to reach.

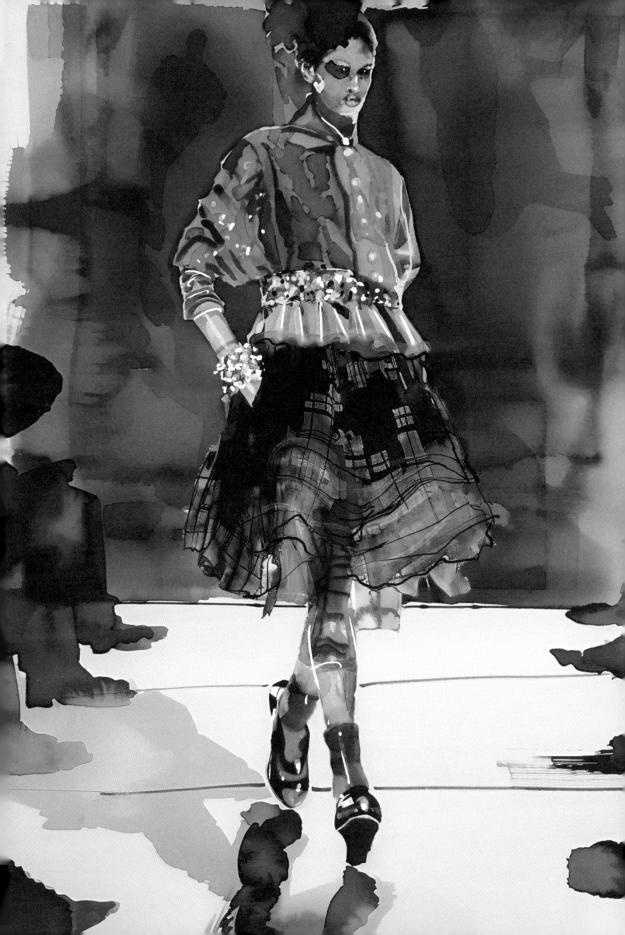

CLIMATE COLLECTIONS

SPRING/SUMMER 2013—AUTUMN/WINTER 2014—15

Westwood's collections started to speak to each other – unfinished hems and kid's drawings, the squiggle print she'd invented all those years ago … She was concerned with what we had and how to be innovative with that. A series of collections followed that focused on climate. They were named 'Climate Revolution', 'Save The Arctic', 'Everything is Connected' and 'Save The Rainforest', and spanned the years between 2012 and 2014/15.

The clothes began to take on a sort of illustrated quality, be it childhood drawings or wax crayon-like lines. This was a concept particularly developed by Andreas. The shows all seemed to connect themes of fragility and fierceness, a need to protect our world and to fight for it. Westwood explored her love of medieval imagery, alongside her greatest design influences, even revisiting the father of haute couture, Charles Frederick Worth.

At this time, Westwood showed just how possible it was to be trailblazing with design and yet foreground messages that needed to be heard. One doesn't come at the cost of the other. In fact, the case might be exactly the opposite.

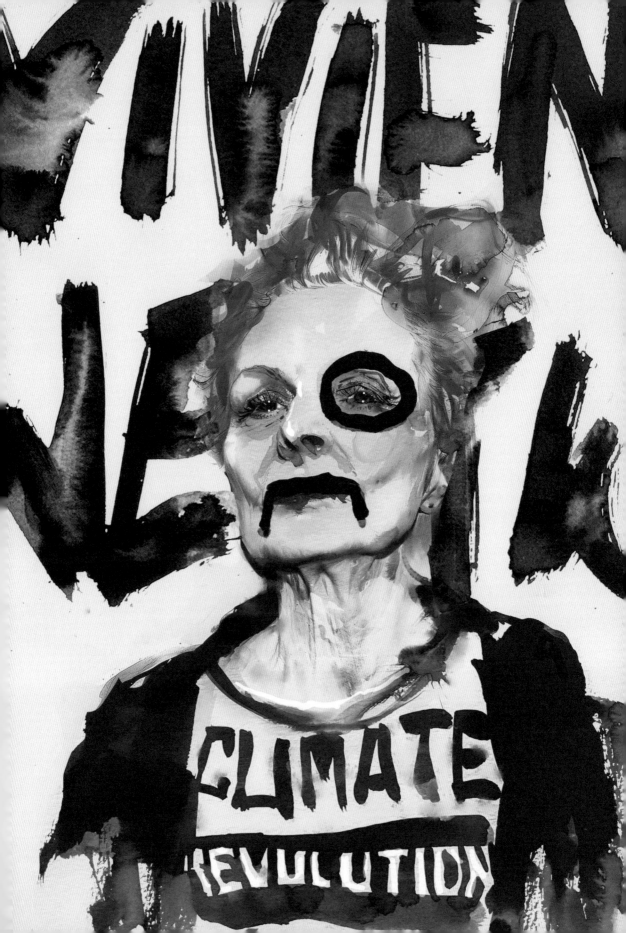

MIRROR THE WORLD

'Mirror the World' was Westwood's final act – her last Gold Label show, in 2016. And it was all about saving Venice (and the world) from sinking. It was a breathtaking ode to the City of Bridges – its culture writ large across the garments, whether in fun, wacky tourist slogans and bric-a-brac stitched across jackets, or repeat prints of incredible Renaissance paintings. Broken mirror dresses reflected the broken world Westwood was so desperate to save. Jackets looked as if they were on stilts, suspended above the models' heads, bringing to mind the supported Venetian palazzos.

The collection marked an emotional goodbye to this label that had totally redefined fashion: not just in terms of design, but also in how fashion could best use its platform to ask for more, for better.

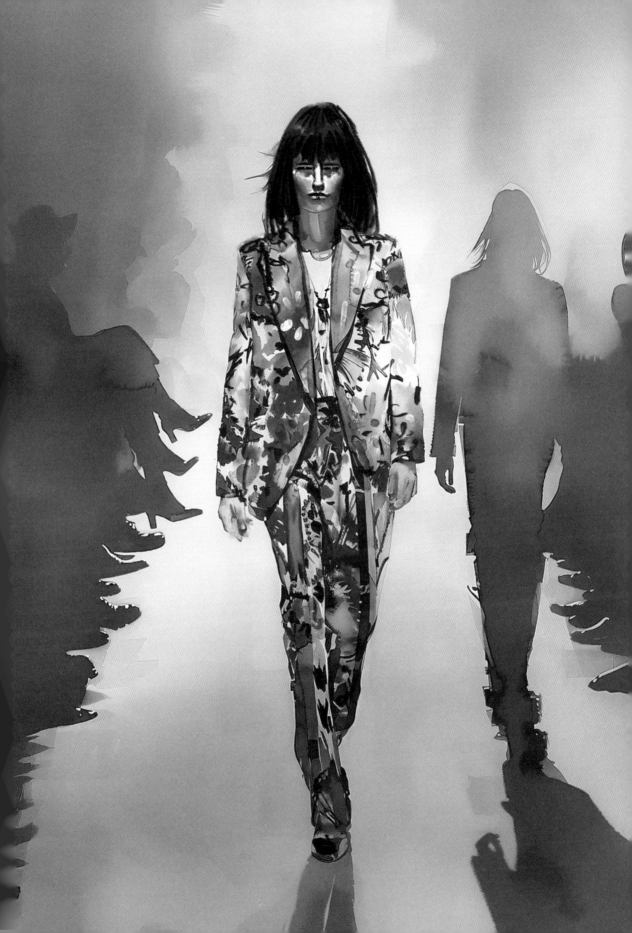

Chapter 11
An UNPARALLELED LEGACY

Vivienne passed away in the last days of 2022, leaving both an unparalleled legacy and a void in the landscape of fashion and culture that can never be filled. She was arguably the world's most innovative fashion designer, designer, birthing and raising movements that would set the world alight again and again. She inspired countless other creators and fashion fans, who believed that clothes had the power to change: the wearer, the street, the culture and the world. Westwood was a cultural force, unstoppable in her constant need to challenge the status quo – in fashion, in activism, even in her own designs.

'I'D LIKE TO BE THE LAST PERSON ALIVE IN THE WORLD! YES, I'D LIKE TO KNOW WHAT HAPPENS.'

She had started out in a small post-war town and wound up on some of the world's biggest platforms. Starting in punk, with Let It Rock and SEX, Westwood created and defined a new rebellious youth culture alongside her peers. Punk grew and grew – and eventually lost its edge – but its heart remained the same: one of rebellion and subversion, of critique of everything. And Westwood shared that heart. So, came pirates, New Romantics, regal beauties and Westwood flashing the royals. Because with Westwood's rebellion there was always love, there was always humour and there was always warmth. This was her position: she was a cultural provocateur who lived and worked firmly on the left. Her self-appointed job was to agitate, always.

Her designs remain completely legendary to this day. She pushed every boundary and redefined countless classics – whether that was the restrictive corset, which became her symbol of female sexuality and empowerment, the tartan miniskirt, her red dresses, kilts, or over-sized power suits. McQueen said that 'Westwood taught people to question everything,' and he was right. Every stitch, seam and structure – both in her clothing and in our society.

When she passed away, the world mourned the loss of a truth teller and a visionary. 'You did it first. Always,' said Marc Jacobs. 'Incredible style with brilliant and meaningful substance. I continue to learn from your words, and all of your extraordinary creations.' Legendary musician Chrissie Hynde wrote: 'Vivienne is gone and the world is already a less interesting place.' And she wasn't wrong.

It's impossible to imagine what fashion and culture would look like today without the impact of Vivienne Westood. In terms of her designs and their effect on culture – she put punk on the map for starters, not just as a style, but as a musical genre that continues to ricochet throughout contemporary music, as well as New Romanticism and the buffalo girls. But Westwood will also be remembered in terms of her unending dedication to hope. Hope for a better world. Hope for more beauty. Hope for more compassion, more ideas, more revolution.

Fashion is now inextricably linked to its political context – but it wasn't always. And it's Westwood who made the link, who forced artists and designers everywhere to sit up and think about the actual world in which they are operating. She was a hurricane, always tearing through a culture that needed it. She, like all revolutionaries, did it not because she hated the world, but because she loved it, and wanted better for it. And she unquestionably left the world in a better state than when she found it.

Long Live Vivienne Westwood!

'VIVIENNE SHOWED US THAT FASHION COULD BE A WEAPON.'
ALEXANDER MCQUEEN

Index

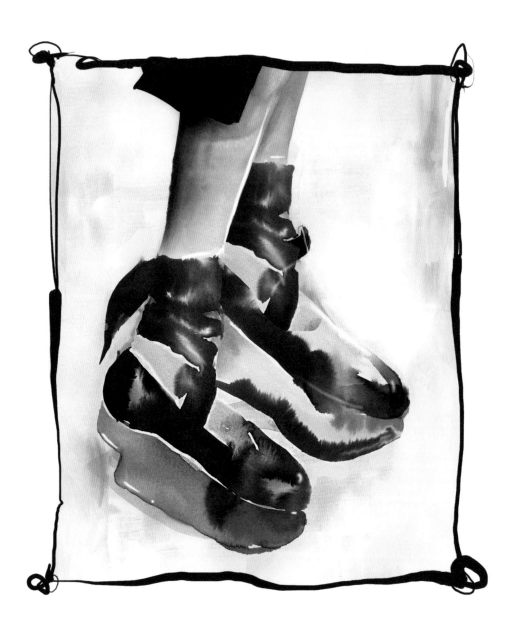

Published in 2025 by Smith Street Books
Naarm (Melbourne) | Australia
smithstreetbooks.com

ISBN: 978-1-9230-4983-3

All rights reserved. No part of this book may be reproduced or
transmitted by any person or entity, in any form or by any means,
electronic or mechanical, including photocopying, recording, scanning or
by any storage and retrieval system, without the prior written permission
of the publisher and copyright holders.

Smith Street Books respectfully acknowledges the Wurundjeri People
of the Kulin Nation, who are the Traditional Owners of the land on which
we work, and we pay our respects to their Elders past and present.

The moral right of the author has been asserted.

Copyright text © Tom Rasmussen
Copyright illustrations © Marta Spendowska

Publisher: Hannah Koelmeyer
Editor: Emily Preece-Morrison
Design and layout: Regine Abos
Proofreader: Jane Price
Indexer: Penny Mansley

Printed & bound in China by C&C Offset Printing Co., Ltd.

Book 373
10 9 8 7 6 5 4 3 2 1